8/2023
STRAND PRICE
$5 00

RADIANT HUMAN

RADIANT HUMAN

Discover the Connection Between
Color, Identity, and Energy

What Aura Photographs Tell Us About Ourselves

CHRISTINA LONSDALE

HARPER
DESIGN
An Imprint of HarperCollins Publishers

A mi vida

Bartolomé José Deler

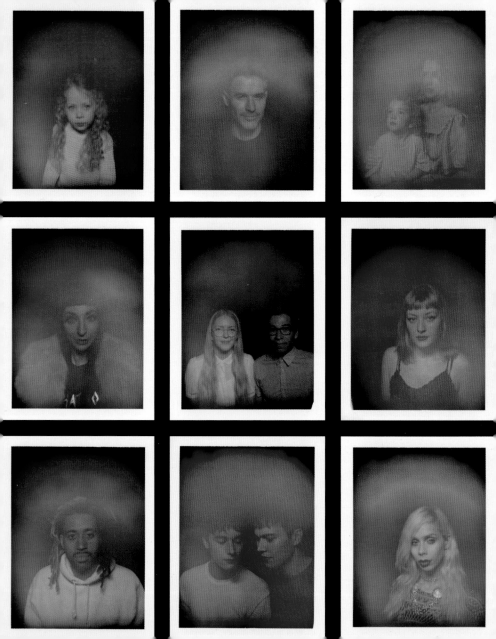

CONTENTS

INTRODUCTION 9

PART I OUR ENERGY SPEAKS FIRST
I Reading an Aura Photograph 35

PART II THE COLORS 67
II RED 71
III ORANGE 89
 Orange-Red 97
 Orange-Red-Tan 101
 Orange-Tan 105
IV TAN 111
V YELLOW 117
VI GREEN 123
 Green-Tan 131
VII BLUE 141
 Blue-Green 149
 Blue-Purple 151
 Blue-Green-Purple 163
VIII PURPLE 167
 Purple-Yellow-Tan 177
 Purple-Red 178
 Purple-Orange 181
IX WHITE 187
X DUSTY ROSE 195
XI RAINBOW 197
XII ENERGETIC LANDMARKS 203
 EPILOGUE 233

ACKNOWLEDGMENTS 235
SELECTED BIBLIOGRAPHY 237
PHOTOGRAPHY AND ILLUSTRATION CREDITS 238

INTRODUCTION

I found I could say things with color and shapes that I couldn't say any other way—things I had no words for.
—GEORGIA O'KEEFFE

Even if you didn't grow up during the heyday of the New Age movement of the 1970s and 1980s, you've undoubtedly felt its influence. Today's emphasis on mindfulness along with a renewed interest in the mystical arts, particularly astrology, tarot, and ritual work, speak to the New Age belief of self-improvement via self-exploration. I've been interested in exploring the nature of the self for as long as I can remember. My upbringing was deeply rooted in this awareness—the New Age movement is part of my family's DNA—and, as an adult, I've continued to search for meaning in our collective perception of the self. I believe that, as humans, we long to make authentic and lasting connections with others. The only way to develop this kind of sustainability in our relationships—both with ourselves and with others—is to become more aware of our inner lives. This awareness is crucial. It helps manifest everything from our career and life goals to our sense of compassion, spiritual consciousness, and well-being. I initially created the Radiant Human photography project because I was curious about a specific kind of camera and its capabilities. What I discovered along the way, however, has transcended my curiosity about a piece of photography equipment and, instead, has led me to contemplate the fundamental energy of our inner selves. This book documents my personal journey and everything I've learned along the way.

9

OPPOSITE: My father, 1969. He has kept a daily meditation practice since 1970.

And while my background is definitely New Age, I also lived through the dawning of the Internet Age: both eras influence and inform my work with Radiant Human.

✳

My parents met in Taos, New Mexico, ground zero for the New Age movement during the Age of Aquarius in 1969. The place and the time couldn't have been more perfect for two hippies—my parents—to meet, thanks to a goat named Foxy Lady, fall in love, and have two children. The story, as my mom likes to tell it: she left California intending to hitchhike across the country with Foxy Lady, getting all the way to New Mexico before realizing that hitchhiking with a goat wasn't very efficient. So she stopped by my dad's commune to try to give Foxy a new home before hitting the road again and, instead, thanks to my father's good looks and hospitality, found her own home among the hippies, the teepees, and the sagebrush. As an artist herself, she found the spiritual focus of the commune refreshing and the quiet mountain mornings a welcome retreat for her creative process. As it so happened, my father's astrological sign is also Aquarius—he came of age in the right place and at the right time to become the founder of two communes, the town's first health food store, and the publisher of *Fountain of Light,* a magazine centered on alternative living for the hippie movement. In its early days, the commune was the kind of place you'd typically imagine: community harvests, outdoor living, and lots of meditation circles.

OPPOSITE, TOP: Foxy Lady and friend, 1969. **OPPOSITE, BOTTOM:** My mother (second from left) at Lorien, the commune where I grew up, 1969. **PAGES 12–13:** My dad's newspaper, *Fountain of Light,* was the hub of the New Age movement in Taos, New Mexico.

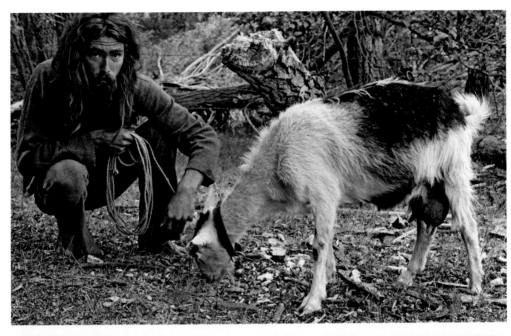

FOUNTAIN OF LIGHT

$.25
N°8 ——————— TAOS ——————— NOV.
♏

LOVE
is

LAMA

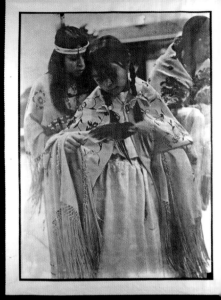

FOUNTAIN OF LIGHT

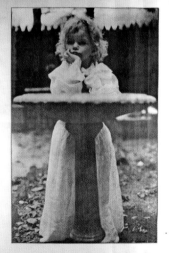

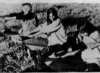

MOTHERHOOD

expectation

General Knowledge

Breathing

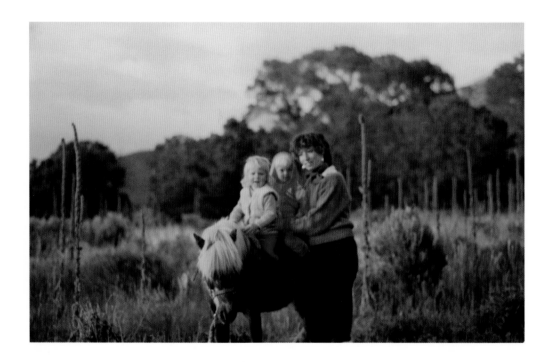

ABOVE, FROM LEFT TO RIGHT: Me, a friend from the commune, and my mother with our miniature horse Dulce, early 1980s. Living there was like coloring outside the lines—the vibe was uninhibited and playful, with a good dose of rascality. I remember bugs, creeks, and an intricate network of footpaths connecting our homes. **OPPOSITE:** When I was little, I loved riding on the bumpy dirt roads in the back of any car and on our miniature horse—the closest thing to an amusement park ride when you're living in the middle of the desert.

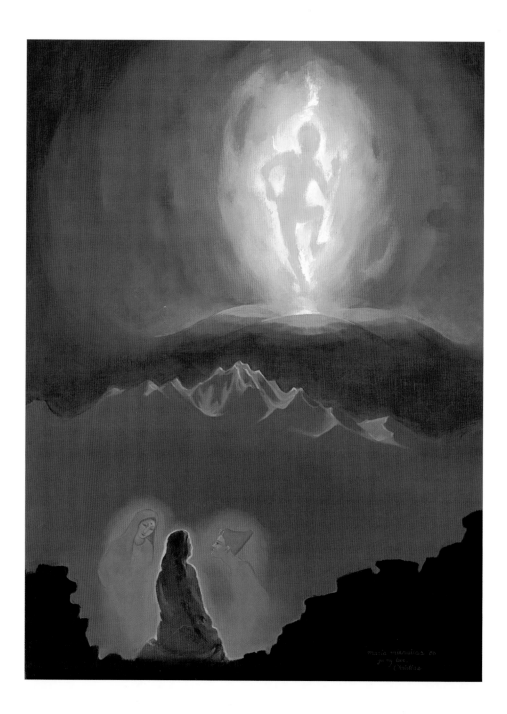

By the time I was born, in 1980, the place had changed: the children of 1969 had children of their own, got jobs, and built houses instead of teepees. The meditation circles became more organized events and the members more invested in the long term. I lived on one of the communes for part of my childhood, growing up surrounded by meadows and open sky, snaking creeks, and free-range animals—a commune lifestyle even if the commune itself had become a more conventional community.

<div align="center">✳</div>

I moved to California and came of age in the 1990s, the decade when the World Wide Web exploded into being at its start and which saw the birth of the handheld Blackberry PDA at its end, in 1999. I grew up amid a backdrop of digital advancements, which had a pronounced effect on how I experienced the world. I can remember, for example, how my friends and I relied on pagers during the pre–cell phone era to communicate with one another during the 1990s rave scene. We called into voicemails and, without navigation, relied on handwritten directions to secret locations, or checkpoints as we called them, to acquire the usually illegal address of a rave. The best part about these parties, however, wasn't their illicit nature. It was finding other kids who were just like us, which helped reinforce the idea that we weren't alone. There was a strong sense of comradery in the early rave days, a prevailing sense that we were building our own secret community—a commune of

OPPOSITE: *The Coming One.* This painting by my mom was based on a dream she had in which she discovered she was pregnant with me. She had the dream before taking a pregnancy test that confirmed what she had envisioned.

sorts—where my friends and I left the outside world behind and were free to create a safe place for other weirdos like us. Much like the counterculture of the 1960s, the 1990s rave scene was a safe haven for other nonconformists to be themselves without the scrutiny of the rest of the world and to explore utopian values like unity and brotherly love. We were, in a sense, digital hippies.

As a teenager, I hated high school. My mother finally agreed that if I studied a marketable skill, I could homeschool myself until I was old enough to take the GED. At fifteen, I enrolled in the Santa Barbara School of Intuitive Massage, where I learned a great deal about the aura—this idea that our physical bodies exist within a larger energetic body, a human atmosphere or aura, through which we broadcast a live feed of our internal state of being. Barbara Ann Brennan's book *Hands of Light* and Caroline Myss's *Anatomy of the Spirit* were huge influences. I read them cover to cover in just a few sittings. I loved the fact that Brennan was a physicist and spoke like one, too. As a child of the New Age movement, I was conscious of the "woo woo" quality of most publications on auras and didn't like them, and feel the same way still.

When I was sixteen, I went to college, where I double-majored in social psychology and multimedia, subjects that were a natural extension of my interests. Whether it was finding the values of the 1960s in the rave scene of the 1990s, exploring the dichotomy of the physical body and the energetic body, or studying the psychological impact of advertising on young women during the beginning of the cell phone era, I've always found myself bridging several ideologies, and it wasn't until social media matured that I found my calling in today's Digital New Age—a social community dedicated to personal transformation through technology and self-discovery.

THIS IS A

TEST

COMING SOON TO A
WAREHOUSE NEAR
YOU

TEST

SATURDAY
OCTOBER ?

THE LEAGUE OF
SPIRITUAL DISCOVERY

LSD

8055646896

ABOVE: When I was fourteen, someone handed me this rave flyer on the street one day. Upon dialing the phone number, you heard a voice recording that gave directions to a checkpoint where you went to buy tickets in person. The location of the rave wasn't released until the night of the event. There were a lot of hoops to jump through, but this was an essential filtering service that kept the party from getting raided and ensured that only those who really cared about the experience attended. The mystery, the adventure, and, most of all, the people that I met there still influence me today.

As an adult, I was deeply inspired by the works of Marcel Duchamp, James Turrell, Cindy Sherman, and the lesser known but equally awesome Nikki S. Lee. Eager to create artwork of my own, I hosted my own scrappy art shows where my interest was mainly focused on pairing intricate color groupings with some kind of revelatory text—my own diary entries, for example—that revealed the various layers of the self. These shows, in a way, were a precursor to my work today. During these early adult years, I got a day job at a department store as a loss prevention agent, which basically meant I walked around the store dressed as a regular buying customer and observed people's shopping patterns to pick out shoplifters and anyone looking to commit credit card fraud. It was an odd job, yes, but it also enabled me to people watch, a skill I most certainly use today, and it allowed me, once again, to explore notions of the self we present with—this time incognito. The only problem was that, as far as jobs go, it wasn't creatively fulfilling. In time, I transferred to a different department, this time becoming a window dresser, where I learned how to dress and style different mannequins and window scenes so that the shopper recognized their own aspirations in what was on offer. After ten fruitful, satisfying years at the same company, I was laid off. For the first time in my adult life, I was living without a steady paycheck, subsisting on what little severance money I'd received and unemployment. Despite initially feeling embarrassed and a bit freaked out at having been let go, I quickly saw a silver lining: I had a clean slate. I could start anew.

OPPOSITE: My older sister Athena has always been a big influence on me and is the true photographer in the family.

✱

Later that same year, while visiting New York City, I accompanied a couple of friends to Magic Jewelry, a cramped crystal shop in Chinatown, to get our auras photographed. Despite already knowing about auras, the concept of photographing one was still relatively new to me. I was intrigued but also skeptical. My friends were insistent that I would love it. Because of their emphatic support of the experience, my curiosity quickly overrode my skepticism, and I soon found myself staring into the reflective lens of a strange-looking camera. A quick snap of the AuraCam 6000 and, a few seconds later, I held my first aura photograph, which was anything but a standard photograph: I saw a faint image of myself beneath a rich overlay of color that corresponded to my energy, my essence made tangible and printed on vintage Polaroid film.

The first thing I noticed was that I was enveloped by a cloud of muddy red; I later learned that this color was an energetic indication of being tired and unhealthy, which was in sync with the fact that I was hungover. I was fascinated by the fact that the photograph didn't show me the way I wanted to be seen—a rainbow would have been nice, or a bright, rich indigo. At the time I thought those were more "spiritually enlightened" colors—and that's how I wanted to be seen. I was fascinated by the tension that the experience produced: I was comfortable telling my friends I was hungover, but somehow having my low energetic state photographed and made visible in a spiritual context jarred my ego. And yet the camera had accurately captured how

OPPOSITE: A great example of a traditional aura image before I began the Radiant Human project. There is more focus on the color and less on the subject.

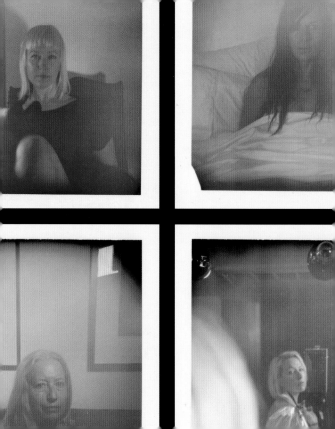

I felt in the moment. I was "caught on camera," so to speak, and this juxtaposition of how I truly felt—or the state of consciousness I was in—and how I saw myself spiritually and wanted to be seen by others became the genesis of my traveling aura photography studio, Radiant Human.

<p style="text-align:center">*</p>

I bought an AuraCam 6000 almost as quickly as I'd gotten my first portrait taken, moving rapidly from sitting in front of the camera to standing behind it. The camera uses FPC-100 film which has been discontinued. In this book you'll see imperfections upon occasion due to the vintage quality of the film. Although new to me, the camera felt entirely comfortable in my hands. It seemed to fully express who I was, bringing together the New Age values of my childhood, the digital space of my adolescence, and the layers of the self I observed in my young adult years. As an artist interested in social media and social psychology, I wanted to take the idea behind the selfie— digital self-exploration and self-actualization through image—but go one step further to showcase the *self* behind the selfie; that is, the energy beneath the construct. The goal was to present energy as identity. To do this, I would need to figure out what each color in a photograph meant. My hope was that in using color as a baseline, I would learn more about the energies it was connected to and therefore gain a deeper understanding of the self. I wasn't interested in regurgitating staid color theory. Instead, I was searching for a collective meaning behind the photographs.

OPPOSITE: In doing self-portraits, I learned a lot by applying my own experiences to the colors I was seeing in others. I loved the images, but needed a backdrop to see the colors more clearly.

The truth was, while I had a working knowledge of auras, I had no experience interpreting them. Luckily, most of my friends and friends of friends were open to a little exploration, and thanks to them, and a few strangers, too, I started to build a sizable collection of photographs, cataloging my observations. I soon noticed consistencies in how people identified with the colors that showed up in their pictures.

Since I didn't have the experience, I began by using references to the chakras, color psychology, and my own aura photographs as guideposts for interpreting other people's images. I found that the more I photographed myself, the more I could relate to others. For instance, when I took pictures of myself during that time, the images consistently showed a combination of red and purple. When someone else would show with the same colors, I often found we had something in common: we were both working very hard (red) to achieve a vision (purple). I found the same thing was true with muddy reds, like my hangover photo in Chinatown, which often did suggest a hangover, fatigue, or something else that was particularly draining. I simply applied my personal experience to the patterns that I was seeing.

With every photograph I took, I tested my color interpretations, honing and refining my theories thanks to the feedback from my friends/subjects. But there was one thing that still bothered me: I couldn't see the subject clearly in the photos. With this type of camera, the aura colors traditionally come out very strong on the photograph,

OPPOSITE: Early experiments where I'm trying to make the subject more visible than aura photographs do traditionally, like the image at the top, where my image is almost obscured. This work resulted in my current style, the signature of Radiant Human, illustrated in the bottom image.

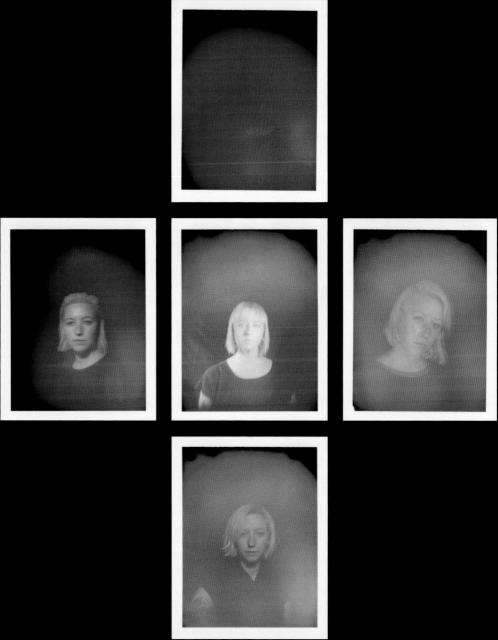

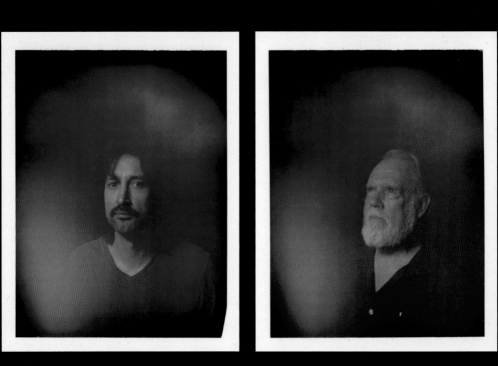

so strong you often can't see the physical expression of the person. I changed this by giving equal visibility to the physical body and the energetic body, further enhancing the juxtaposition of the self and the selfie.

After months of perfecting my process, I had the idea to take my photography project on the road to further test my findings and to get a wider range of subjects. The only problem was funding. Since Radiant Human was self-funded and the film and travel costs were expensive, I needed a way to keep the project sustainable, so I had a focus group with several of my friends who owned small businesses to nail down details, like how much to charge and how much to save for taxes. I had no idea if I would make enough money or how long it would take to get the photos I needed. It was a big guessing game. Little did I know that I'd be living from a suitcase for the better part of five years, traveling all over the country. After taking more than forty-five thousand photographs, I began to see the meaning behind each color and why they combine the way they do—or don't. Forty-five thousand photographs may sound like a lot, and it is. Compared to the rest of humanity, however, it's a small sampling. While I've been able to establish a fairly consistent way of understanding what I'm seeing, I fully recognize that I've barely scratched the surface. There's still much to uncover and learn. That said, I'm happy to present my findings here, and am excited to continue to explore the connections between color, energy, and the self.

29 —

OPPOSITE: It's always shocking to see similar colors coming from people I know well. In this case: my first boyfriend (left) and my father (right). These images were taken six months apart and in different parts of the country, yet they're almost identical in coloration. Both men are sensitive and thoughtful (blue), highly opinionated (green), and visionary (purple).

THE DOME

Because I wanted Radiant Human to travel, I needed a consistent and portable workplace that was both easy to set up and to strike down, and readily identifiable to anyone following my work. Technically speaking, the dome isn't necessary to what I do; the camera's hand sensors work just as well outside the dome as they do inside it. The dome is a portable, controlled environment, and, in that sense, it's as essential as the camera. This is my observatory; much in the way we use telescopes and space-based equipment to study the greatest mysteries of the cosmos, I wanted to utilize the AuraCam 6000 and the dome to contemplate the great mysteries of the self.

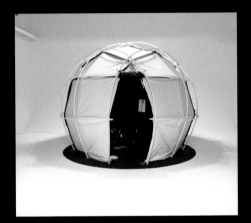

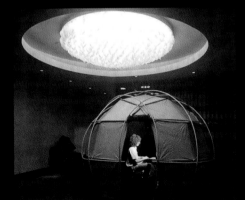

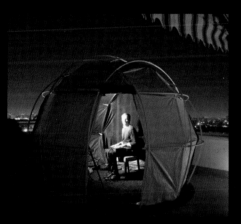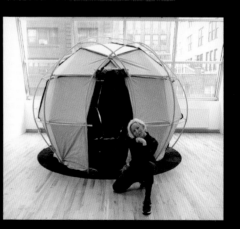

An aura photograph captures a moment in time. Things change and you do, too; we're all on different cycles, and our individual journey isn't linear. While some individuals may have a core energetic identity—see page 219—those identifiable characteristics may shift depending on an individual's life situation. We're much more complex than our selfies, and yet we're conditioned by society on how to perceive the nature of people or situations without knowing all the details. The same can be said about color itself. A common misconception, for example, is that white indicates higher consciousness. In my experience, however, I've found that it simply indicates energetic overload.

You may be able to fake your physical appearance, but you can't fake your energy. Our energy radiates around us and broadcasts into our environment for everyone to witness and experience whether you like it or not. An aura photograph simply puts this in perspective. It's not a typical selfie—a customized fabrication that suits how you want to be seen by others. Instead, an aura photograph is a more genuine portrait, illustrating who we really are when faced with the complexities of a particular moment. In the image-obsessed Digital New Age, I want to tip the scales and place just as much importance on our energy as we do on the way we look.

Radiant Human works on two levels: every photograph captures the physical representation of the subject—his or her image—and the subject's energetic state. Which one is more real? The physical world or the energetic? An aura photograph reveals the depths of both the energetic and the physical self. The greatest revelation, however, lies in the space between the two. My hope is that, in looking at the volume of images in this book, you'll begin to make your own connections, discover a new perspective or sense of self, and view the vast and complex human experience in a new and colorful light.

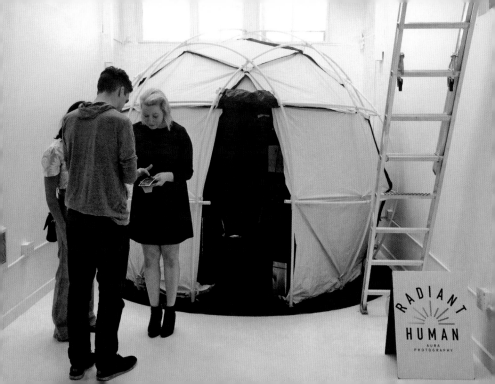

OUR ENERGY SPEAKS FIRST

CHAPTER 1 Reading an Aura Photograph

My work is based on a combination of intuition, research, and data sourcing, and yet none of it would be possible without the AuraCam 6000. Invented by Guy Coggins, the AuraCam 6000 was originally the purview of crystal shops, psychic fairs, and New Age gatherings. It was initially used as a service enhancement for psychics or, in some circles, as a kind of alternative healing apparatus whereby one could glean information about an individual's aura and prescribe remedies or practices to help manage or direct the energy. Despite these good intentions, the AuraCam 6000 has been controversial in its ability to accurately detect any health issues, and, let me be clear, I do not use it to heal, "fix," or diagnose anyone.

The AuraCam 6000 is unique in that it comes with hand sensors that gather data—electrodermal readings—via key acupuncture points on each hand. Photography subjects place their hands on these sensors while the photo is taken. The data is then analyzed according to a proprietary algorithm designed and developed by Coggins himself that translates the energy of the photography subject to a color on the visible light spectrum. Because both color and energy are comprised of wavelengths, they correspond to each other: the algorithm essentially matches wavelength A to wavelength B. This is a double-exposure process: the first exposure is a regular portrait, and the second is an overlay of color on the portrait that corresponds to the wavelength of energy being read by the sensors. Think of the overlay as energy made visible by color and printed on instant Polaroid film.

Along with the sensors, the camera also comes with a user's manual of sorts. This manual is a simple graphic explanation of how the camera distributes color into three sections of the photograph. Traditionally, the lower left-hand corner of the

35

photograph supposedly corresponds to the past, the lower right to the future, and the area above the head to the present.

I was skeptical that a camera could predict the future, much less photograph it. After taking several photographs of myself as well as other people at five-minute intervals, and then in intervals of days and weeks, I did notice changes in the colorations, but they didn't necessarily correlate to the past or the future. The only colorations that seemed to be accurate were those that presented in the area above the head, the present.

On the opposite page are three consecutive self-portraits I did five minutes apart. The first photo has purple in the lower left-hand corner and blue in the lower right-hand corner. If this camera shows the future via the lower-right corner, the logical thing, I imagined, was that the second photo would show blue over my head. But it doesn't show blue: it's mostly purple and orange-tan. If the camera shows the past via the lower-left corner, I would have expected the colors to change, but they did not. The third and final photo is an amalgamation of the first photo's bottom half with the second photo's top half. This suggested to me that the camera wasn't randomly choosing color; it was reading something, just not my past and future.

Seeing this discrepancy was thought-provoking. Was this camera randomly spitting out color? Was it a fake? Upon further investigation, I observed that the colors showing up weren't random. They remained more or less within the same color family, but with subtle changes. I decided that instead of looking at the photos for what they might tell me about the past and the future, I'd look at the entire photo as a capturing of the moment, a literal snapshot of what is going on with our energy in

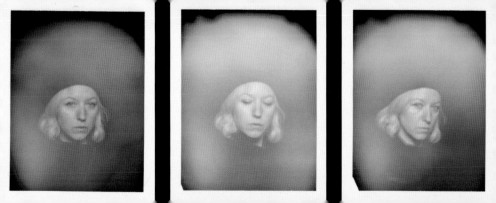

RADIANT HUMAN DISTRIBUTION MAP

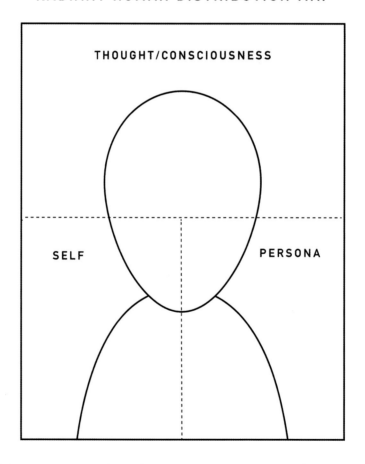

THOUGHT/CONSCIOUSNESS

SELF

PERSONA

live time. After several trial-and-error sessions, I came to interpret the sections of the image in a way that resonated with what I saw in the images, and what I saw was validated by my subjects. The photograph can be divided into three areas, which I refer to collectively as the distribution map (opposite) and read as follows:

- Lower left-hand side of the photograph: internal energy, or the self. The internal energy, or the area of the self, governs your emotional processing and represents your internal state—the person you are on the inside. For some, this can best be described as an intuitive quality, a secret, or a feeling. This area governs the core sense of who you are, what's going on internally as well as the intuitive sense of what needs to happen. This area is where both your innermost desire and turmoil are located. If no color is present, then you most likely need more self-care, although I've also seen an absence of color in that area among people who report experiencing a "clean slate" moment in their lives where they aren't feeling particularly grounded in one version of self or life goal. Either way, there's no color, so there's no energy.

- Lower right-hand side of the photograph: external energy. The self you project to others. Think of the external energy or persona area of the map as the version of ourselves we present to the world; it's our work face, how we interact with the external world and its corresponding pressures. This is the area that represents whatever energy we lead with and whatever skills we have in relating to others. Some people have one color in this area

while others have many, and, depending on the combination of colors within that category, it can represent everything from a "jack of all trades" to someone who displays mixed messages. If there's no color in this area, then the person is usually holding something back either on purpose, like a secret, or is naturally guarded as with the case of most introverts.

◆ The area above the head and the space surrounding the ears: the mental energy of thoughts/consciousness. The space above the head naturally correlates to our mental state, anything and everything we do that requires mental processing—from decision making to big-picture creative thinking. It's important to note that mental processing is different and distinct from the internal negotiation of emotional processing; the colors bear this out in a real way, with some (like dusty rose) appearing in the mental area but never, in my experience, in the internal and external area. I see color changes most often in the mental area, which isn't surprising since our thoughts and moods frequently fluctuate. If there's no color here, or the color is uncommonly low in the space or closer to

OPPOSITE: A group dynamic. After photographing many people who work together I came to realize that you can read the energy of a group as well as an individual. This team supplies an online platform for small vendors selling handmade goods; the majority of orange in their portraits not only suggests that the workplace draws those individuals who collaborate well with many personalities and are creative problem solvers, but also speaks highly of them as a team.

the ears, I usually check my camera and take another photo, because that usually indicates that the sensors aren't plugged in properly. A low aura, however, usually indicates someone who's heavily guarded and possibly stubborn or narrow-minded and/or very mentally fatigued.

Applying these interpretations to my own self-portraits (page 37), you can see that the lower left-hand corner didn't change much for me, and it doesn't for most people, as it's usually representative of our core internal selves and whatever we may be processing on a personal level. The lower right-hand section of the photograph is representative of forward-moving energy; that is, energy we use to present ourselves to the world. This corner was the area that changed most often when I myself looked in the reflective surface of the camera. In addition, the area above the head also changed on occasion for others and myself. This area is representative of the energy of our present state of mind or being; it's usually indicative of whatever thoughts, ideas, or mental processes we're contemplating in the moment.

The meaning behind certain colors or combinations is wholly dependent on where they're located in this triad. So, for example, the image at left on the opposite page shows a muddy maroon in the lower left-hand side, the area of the self. This may suggest this person is at a crossroads or is in need of more self-care. If the same color is located in the lower right-hand side of the photo, as it is in the image at opposite, right, it may simply represent superficial fatigue, like being stuck in traffic. It also

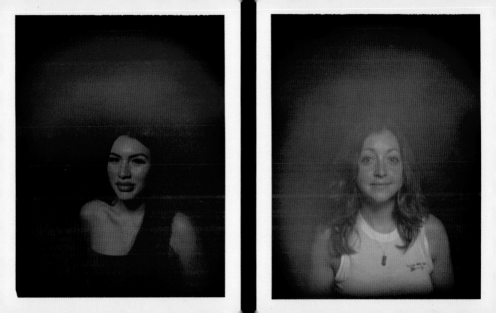

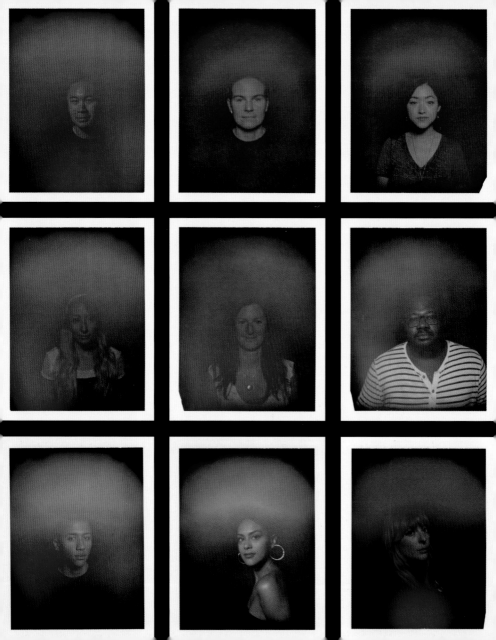

indicates a need for self-care when this area takes on a faint muddy hue. That said, I've also encountered individuals who report the sensation of having a clean slate when there is little to no color in one or more of these corners. In these cases, a lack of color, not the muddiness, may indicate clarity and openness for the next stage in life to begin; the person may be in a state of transformation. The individual meanings of each color will soon become clear. For now, it's enough to simply remember that the placement of color matters just as much as the color itself.

Just as the placement of color matters, so too does the absence. As explained above, an absence of color in the lower right-hand corner of the photograph—the area relating to external energy—typically indicates someone who's more introverted or shy. Skeptics may also have an absence of color here. Whether someone is either naturally withholding their energy or is doing so intentionally—holding back their energy and/or being more guarded—both present with the same absence of color.

OPPOSITE, TOP ROW: Images with little to no energy in the lower left corner. **MIDDLE ROW:** Images with little to no energy in the lower right corner. **BOTTOM ROW:** Images with no energy in both lower corners. An absence of color in both corners typically means that all the energy is directed to the mental space above the head instead.

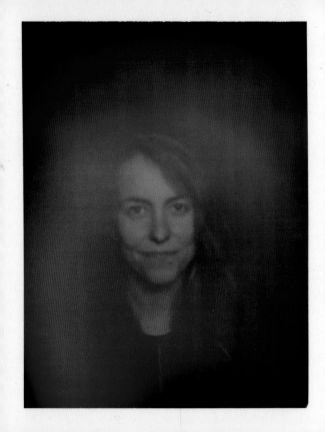

DISTRIBUTION OF ENERGY
Riley Self

These images of Riley Self not only explain the three areas of the distribution map, but also capture a universal heartache: while I was working with Riley, she was processing feelings and changes that accompany a breakup. The colors she presented reflect her emotional transition to beautiful effect. In the first image, there's a big fireball of red lodged in the lower-left corner (internal experiences). For most people, red represents a change of some kind. Whether the change is related to a person's career, pregnancy, or relationship, most people will show red in the lower left area of the distribution map when anticipating change or friction that hasn't yet been vocalized or made public.

In Riley's case, she was anticipating, but not wanting, the change in both her relationship and her career. In this instance, her relationship is represented by blue; her career is green. The blue-green dichotomy is classic. (For more information on these colors and this dichotomy, see page 149.) Mentally, Riley was trying to balance her relationship (blue) and her career (green) while being aware that change in her life (red) was lurking.

The second photograph was taken months later, post-breakup. You can see that her colors have changed, with

"I was anticipating but not really wanting change. I was trying to focus that anticipation in my career and was doing a lot of research into the paths I could take. I also was in an unsteady point in my relationship. We actually did a couple's picture right after this, sort of in hopes of understanding where we were emotionally, but there were a lot of things we were working on at this time. I wasn't spending much time with friends either, mostly just working and being with my partner." –Riley Self

red disappearing entirely, leaving nothing in its wake. The only visible color is above the head, a phenomenon I regularly see whenever someone is so mentally consumed with something that they have little energy for anything else. The reason or reasons behind this mental concentration varies from person to person, but the result is always the same: a vacant space below and color above the head. This isn't bad; it's natural. For some people, no color means they're "in their head" over a particular issue, while others can drop into this state when they're overcome by inspiration.

In Riley's case, she was still living with her ex post-breakup and, in her words, "unable to think of anything else," hence the concentration of color in the mental area of the image. The quality of thought is represented by the color and tonality in the image. Here there's plenty of blue, which represents feelings; white, which represents a state of being overwhelmed; and purple, which represents ideas or daydreams. These colors aren't tidily arranged but, instead, are all mixed up—almost blurry—and paint a clear picture of how most of us feel when experiencing a breakup.

In addition to color and tonality, there are details in an aura photograph that can enhance understanding, so let's focus more closely on how the distribution map works.

OPPOSITE: This photograph captures Riley's recent breakup. She reports feeling "pretty down, but trying to stay positive. Not really able to think about much else."

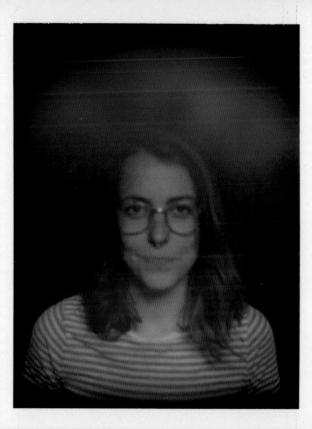

THE CHARACTERISTICS OF THE AURA PHOTOGRAPH

Before we explore the colors themselves, it's important to understand some additional terminology. Colors typically display themselves in one of five different categories, each with its own specific meaning:

- · BANDS
- · BRUISING
- · GRADIENTS
- · SHADES/BLENDS
- · DOTS

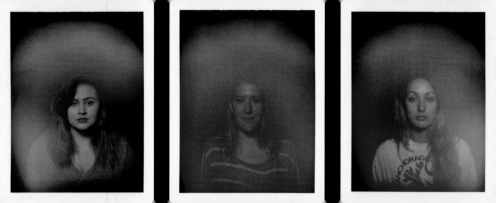

BANDS

A band of color is a long strip or narrow line of color (or colors) that form an arc above the head. A band represents your goals or what you hold above yourself, like a priority or an ideal. A band always appears in the mental area, so this is mental energy. The image can take on different meanings depending on what colors make up the band. So if you have a purple band above your head, you most likely have a belief or a philosophy that you hold above yourself. If you have a band of blue, you prioritize loyalty, relationships, and a sense of belonging. If you have two colors in a band, things can get interesting. Some colors, like tan and green, for example, are natural companions because they have similar interests and reward systems (green is growth-oriented, while tan loves to plan and control). If a band is comprised of colors that have contrasting reward systems, it typically represents a negotiation of some kind. A yellow-tan band is common, as it represents mental negotiation: yellow wants to be free, and tan thrives on discipline and structure. If there are clumps of color rather than a clean band, it indicates the sense of conflict is stronger.

OPPOSITE, LEFT: This band shows several colors. Judging by its coloration and the chunky quality of the hue of her aura, Hailey is most likely in a state of mental negotiation between letting go (yellow), control (tan), adaptability (orange), and practicality (red).
CENTER: The green band indicates that Ashley is working toward a long-term goal.
RIGHT: A blue band indicates that Ashton prioritizes trust and the feeling of connection to a community or a relationship.

BRUISING

There's another type of coloration I refer to as "bruising," because the combination of colors literally looks like a bruise—darker but distinguishable chunks of color mixed together. Bruising is an indication of duality and embodies the positive and negative traits of a color. It's typical for green types, for example, to be self-critical for not reaching their goals fast enough. (See page 123 for more information on green.) If the bruise has a dark chunky quality of Forest Green rather than a lighter, Kelly Green version, this may indicate that the individual is experiencing the negative aspects of the color—being hard on oneself—more deeply. This is, of course, dependent on where the bruise presents itself on the distribution map, although it is most commonly found in the mental area.

OPPOSITE, TOP LEFT: The blue-green bruising in the upper-left portion in the area above the head indicates mental exhaustion not only because of the push-pull dynamic of blue-green, but also from trying to manage the variety of colors (energies) present in the other areas. **TOP RIGHT:** Purple bruising in the mental area represents idealism or tension around a concept or vision. Here, the warmth of the purple indicates that Veronica is likely dealing with the practical, hard work necessary to realize a dream or project. **BOTTOM LEFT:** Green bruising in the mental area represents impatience, or someone being hard on themselves. **BOTTOM RIGHT:** Red bruising in the mental area represents fatigue from change or a demanding situation. In this case, Hayden was exhausted from a recent move.

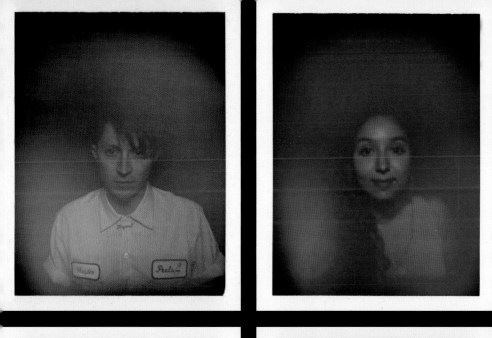
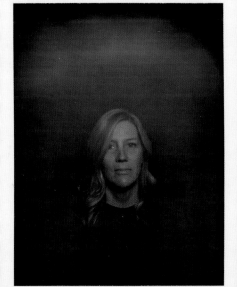
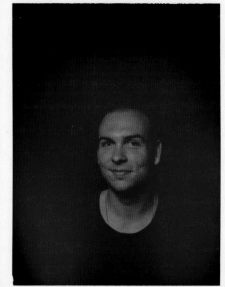

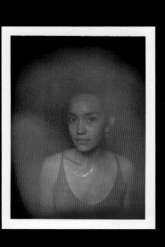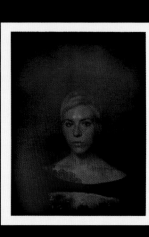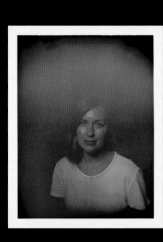

GRADIENTS

A gradient occurs when two different colors are found in the same area on the distribution map. Rather than being combined, the colors layer like a parfait, indicating duality or a dynamic between the two. Depending on the personality traits and reward systems of the colors involved, the combination may or may not be harmonious. Yellow and orange, for example, are two colors that work well as gradients because they have similar reward systems, whereas blue and green do not.

On the opposite page, the photo at the far left has a band of green that gradates to tan and orange in the area above the head. The tan-orange is almost blended, but there's a slight definition of color on the upper rim. The green band indicates Rosa is prioritizing a long-term commitment; tan indicates the attention to detail associated with planning and the anxiety associated with perfectionism and a fear of failure; and orange offers the creative thinking and adaptability needed to be comfortable with risk. The tan and orange are mostly blended, indicating that orange can counterbalance tan's anxiety, making it far more likely that Rosa will be capable of taking the risks needed to accomplish her goals. In the center image, the tan and orange gradient in the lower left-hand corner represents the internal negotiation between risk (orange) and security (tan). Kamela's mental energy is growth-oriented green, which hints that this negotiation involves her plans for the future. Her external area (lower right-hand corner) lacks color, which suggests she's holding back until she resolves this negotiation. Finally, on the right, Megan shows a gradient of blue and purple in the external area, which means she possesses introverted and extroverted qualities. Purple represents concepts, while blue represents sensitivity, so while she seeks out inspiration and enjoys sharing ideas, she most likely needs to be comfortable in her environment before she can do so.

SHADES/BLENDS

A shade and a blend are interchangeable terms, indicating a synthesis of two different colors—orange and tan, for example—within a single area of the distribution map. As opposed to a gradient where the colors are separated, when two different colors blend together, it usually means they support and enhance each other's characteristics. This means the colors are integrated, like a special skill or superpower. In the case of orange and tan, which are not typically harmonious, as orange is spontaneous and tan is methodical, a shade/blend indicates a person who is organized and adaptable. This is a color trait that I commonly see with producers and personal assistants.

The concept of a shaded/blended color, however, can be a little tricky: in painting, yellow combined with blue makes green. The same, however, doesn't hold with aura colors; each color is its own identity. Individuals who identify as green types, for example, don't have yellow characteristics mixed with blue ones. Yellow typically signifies optimism, and blue, sensitivity. Yellow and blue together in an aura photograph suggest a sensitive optimist, which isn't what green typically suggests.

OPPOSITE, LEFT: This shade/blend of blue-purple has some magenta above the head, indicating visionary strength, although the slightly muddy hue suggests Ratnanjali is mentally fatigued and feeling tense about her ideas. **CENTER:** Note the white with a bit of green here. When blended with another color, white represents that color's fractal nature. White combined with blue may suggest the person is having many different feelings; white with purple, having many different ideas; white and green, considering many different directions. Since these colors are all located in the mental area, Kara may be dealing with various feelings, ideas, and directions at once. She may feel overwhelmed or be in transition, especially with an absence of color in the lower corners. **RIGHT:** The clean blue-purple in the mental area suggests Ecko dedicates a lot of energy to all manner of relationships and inspirations.

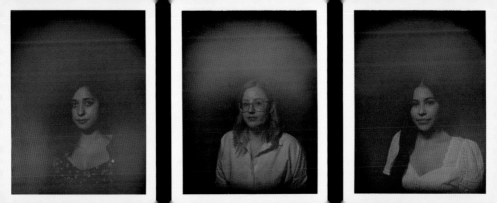

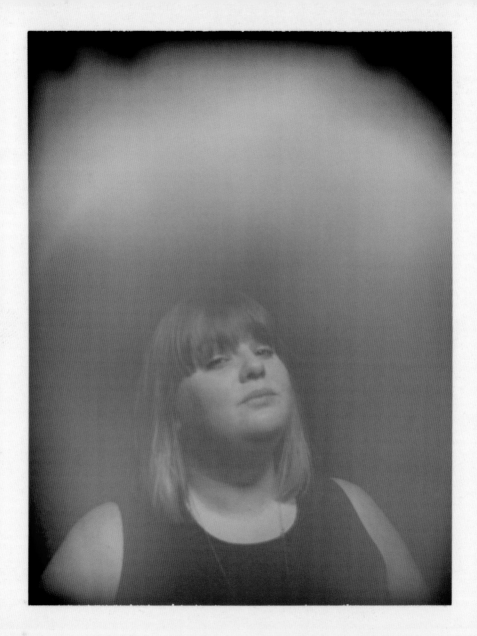

A person with green as their driving energy is more of a productive type who revolves around growth and setting goals.

A specific example of a shade/blend is the combination of tan, orange, and yellow. If this shade/blend shows up in the external area of the distribution map, it usually indicates someone who's incredibly adaptable at their job or in their career, graced with problem-solving skills (orange); organizational, structured thinking (tan); and an outgoing personality (yellow). This coloration is a kind of energetic uniform; it is in a sense how someone presents themselves at work or to the world at large. For this reason, it can be more of a learned or trained behavior rather than an internal orientation.

Finally, a quick word more about the differences between a shade/blend and a gradient. Whereas a shade/blend indicates an integration of the colors—a fusion of various energetic states and qualities—a gradient shows the dynamic between them. If the shade/blend shows up in a band, this shows the fusion of those energies as a priority. If the band is a gradient of two or more colors, then the subject is showing multiple priorities. Depending on the compatibility of the colors present, these priorities are either conflicting or harmonious.

OPPOSITE: Erin displays a shade/blend of orange-tan with yellow as a band in the mental area. She is adept at prioritizing when there are many tasks at hand (orange), both efficiently and effectively (tan), and with a sense of humor (yellow). The white-purple blend in all areas of the distribution map speaks to her mental, emotional, and physical engagement with a variety (white) of concepts and ideas that correlate to her belief structure (purple).

DOTS

A dot is a pattern of coloration found exclusively above the head. Dots look like spots or paw prints. It's a common belief to think a dot indicates the presence of a spirit guide or guides, but I have not found that belief to be accurate. I have two spirit guides that have been with me consistently from childhood, and I haven't seen very many "spirit dots" in my photographs. This was another instance, like the distribution map, where I deviated from tradition and paved my own way. After countless interviews and personal observation, I concluded that a dot represents intense mental processing. It can sometimes look like a storm cloud and can indicate an overwhelming or transitional energetic state.

Dots may appear in an aura photograph, but if the subject is photographed again—whether days later or months later—they rarely appear consistently.

OPPOSITE: Throughout my practice I have come to believe that we all have spirit guides. While traditionalists commonly believe spirit guides are represented in the form of "spirit dots," I disagree. I believe the dots represent strong mental activity.

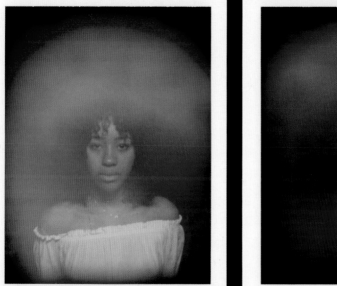

PHARRELL WILLIAMS

When I photographed Pharrell Williams in 2017, he was hosting ComplexCon, a major event that required him to be on a tight schedule and juggle a mix of logistics and priorities. The images feature a significant amount of tan and orange in the band above his head, which makes sense, as the arc of orange (diplomacy) and tan (discipline) above his head shows that he's good at applying both toward the intention of reaching his goals.

With a creative individual, it's not at all surprising that purple (conceptual thinking) is in the mix. Blue—the purview of family, community, trust, loyalty, and human connection—shows up in the lower right-hand corner of the distribution map and points to the importance of relationships in his life and the sensitivity he has about his surrounding environment. The orange in the lower left-hand corner combined with tan is indicative of how the detail-oriented aspects of his personality (tan) interact seamlessly with creative risk and collaboration (orange).

THE COLORS

When Isaac Newton first passed white light through a prism and watched it fan out into a rainbow, he identified seven colors—red, orange, yellow, green, blue, indigo, and violet. While there are more than that, he initially organized this spectrum to correspond with the seven notes of the musical scale. It's telling that humanity's earliest attempt at color identification hinged on the musical, the vibrational. Color, it seems, is something that can be felt or experienced—at the very least, certain colors resonate with us emotionally.

This is true of the chakra system, too, where each energy wheel corresponds with a color. In this system, purple is located at the crown of the head and represents higher consciousness or enlightenment, while red is somehow more primitive, as it relates to the root chakra, which channels our basic survival urges. In my experience of photographing and speaking with thousands of people about their lives in the context of energy and color, I have seen the tendency for people to apply a hierarchy to these color attributes, but I can say with certainty: there is no best or more spiritually enlightened color. Each color and hue, and their combinations, carry a full spectrum of positive and negative attributes entirely specific to the individual and the moment during which they are photographed.

In this sense, color can vary as much as people do. Two people may both have yellow auras, but the way in which the color is interpreted can differ greatly due to its hue, its location on the distribution map, or its combination with another color. That said, there are some patterns and qualities that generally hold true for each color, so I've included an explanation of each color's positive and negative attributes in their respective sections.

Lighter hues of colors have different connotations, depending on the quality of the lightness. A lighter hue usually embodies more positive qualities and characteristics, but don't confuse a lighter hue with a white shade. White is its own stand-alone category, and consequently a white shade or blend has its own meaning (see page 187).

The color spectrum of the aura correlates to Newton's system in that it includes the colors of his rainbow, with a few notable additions: white, tan, and purple. Within these categories, I've identified some archetypal color combinations, pairings I see repeatedly. There are also variations on the spectrum of the aura, with some colors blurring or blending into others to become their own identifiable hues (as with dusty rose and magenta). I've highlighted these outliers as subcategories within larger categories of color.

I have also seen entirely different shades/hues come from other aura cameras that I have never seen with my own, which I can only assume is because they are working with a slightly different algorithm. My interpretations of these colors are based on multiple factors: my firsthand experiences both crowdsourcing information and feedback from the subjects of the more than forty-five thousand images I have taken with the same camera, standard color theory, art history, and psychology, as well as alternative and/or non-Western understandings of color.

When organizing the images for this book, I found that the same photograph could be applicable in several different color categories, and that's because we are a multitude of color and energy. We are all several different and often changing combinations of personal experiences, thoughts, and emotions, radiating a certain energy in a specific moment. There's potential for all of us to show any and all these colors—alone and in combination—over our lifetimes.

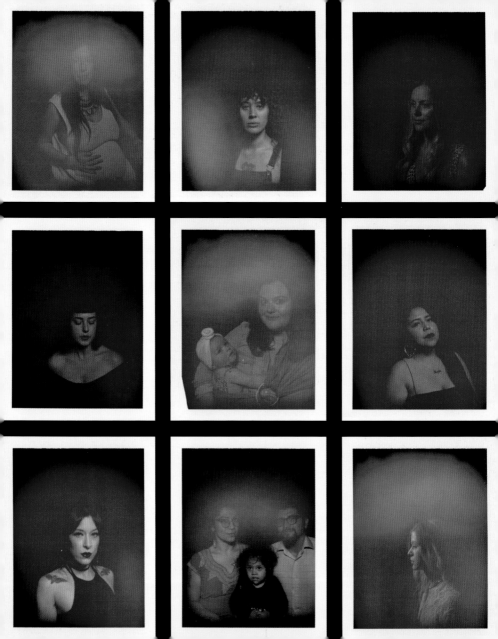

RED

A flame is rarely red—it's more often orange, yellow, blue, or sometimes white—and yet red has long been associated with the idea of fire. Perhaps this is because fire is perceived as being a force of nature, something as elemental as blood itself, that truest red. As the color most associated with fire and blood, red is archetypal. According to the earliest Eastern traditions, red corresponds to the first and most base of the seven chakra energy centers, the root Mūlādhāra, which acts as the foundation, the starting point, of energetic development. For thousands of years in Western culture, red was the color par excellence, considered by many the first color: man's earliest cave drawings were rendered in red (although not necessarily for any other reason than that was all they had on hand, along with charcoal), and it's likely that our ancestors also painted their bodies with the symbolic hue, a practice that's continued today with red lipstick and pinkish blush.

With the rise of the Protestant Reformation, however, red began to fall out of favor. According to sumptuary laws of the time, the color was considered garish and depraved, the purview of the immoral. What was once understood as being associated with a positive life force instead became associated with the crimes of blood and the flames of sin. Today, we still battle with its seemingly contradictory qualities. Some love its intensity and sense of passion, while others viscerally avoid it, associating it with aggression, rage, and uninhibited sexuality.

OPPOSITE, TOP ROW, LEFT: Pregnant women often show red, which makes sense since pregnancy is so physical, never mind its overarching themes of change and birth—all the realm of the color red.

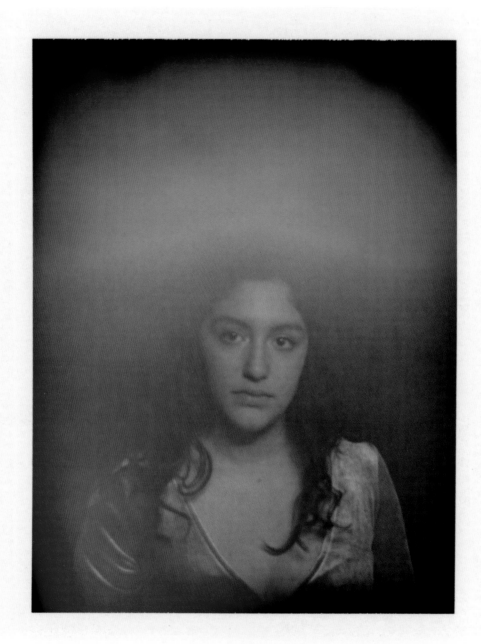

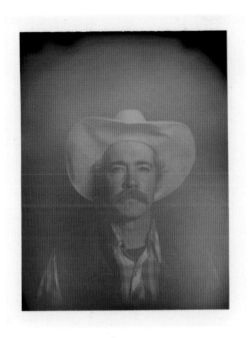

I love talking about red because it's generally so misunderstood by both aura photographers and photography subjects alike; where they see someone who's "tired" or "unhealthy," I see someone going through a major event, like a pregnancy, for example—of course they're tired, but that's a shortsighted explanation for someone in the midst of a big change. There's more to red than meets the eye. Yes, it's powerful and intense, but it's also deeply nuanced, especially in its sister shades: muddy red and magenta. With the slightest shift in hue or blend, red can reflect either visionary strength or exhaustion.

Red is the slowest of all the wavelengths within the visible spectrum, yet it's also the most stimulating color. Red stimulates specific cones in the retina so the viewer's energy and attention are focused outward. Red demands attention—think of stop signs and stoplights, past-due notices. It elicits primal reaction. For a color that stirs up such a heated response, red also connotes practicality. When it presents in an aura photograph, it usually signals a reaction to something or the pressure to be practical about how a decision or a project is going to work in reality. Red-dominated auras often indicate a person who's going through change or is on the verge of change—a romantic breakup, a change in employment or living situation,

OPPOSITE: Notice the red in the lower left-hand corner of the photograph, which indicates an internal pressure most likely due to the blue-green dynamic. See page 149 for more on blue-green.

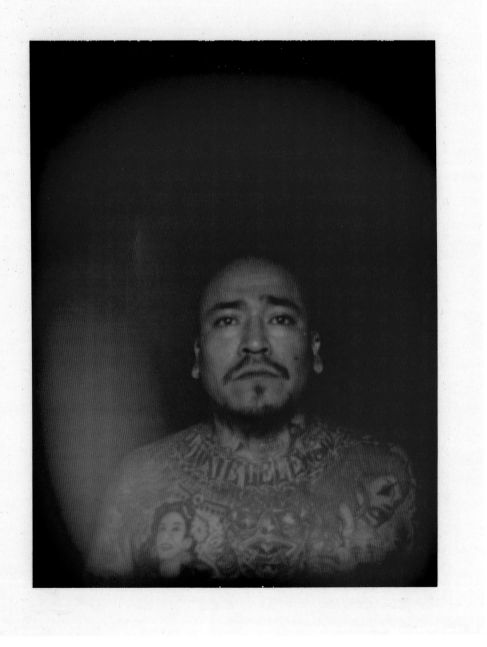

or any other type of major life-changing event—and who needs to make practical decisions to determine a course of action. Sometimes, red simply indicates a person who is already practical by nature, someone who knows how to apply pressure to get things done. Both scenarios carry the same energetic tone. They're just two sides of the same coin.

If someone displays a significant amount of red in their photograph but isn't experiencing an upheaval or some change, they often report a sense of validation in seeing a physical difference as a result of their efforts. Programmers, gardeners, and some artists tend to photograph with combinations of red, as do people who do physically demanding work: dancers, massage therapists, manual laborers, athletes. People who work in creative industries, like fashion or events, for example, tend to photograph with a combination of purple and red, with purple representing the creative mind, red representing the birth process or the state of manifestation, and the combination reflecting the process of bringing a concept to fruition.

There's also another type of person who tends to present with a lot of red: the skeptic. Skeptics want to understand reality in tangible terms. They operate in the material world and, as such, want physical proof of a concept or idea; they need to see it to believe it. This energetic tone places more value on producing tangible results; they identify as being

OPPOSITE: Purple and red often represents the physical implementation (red) of a dream or an idea (purple), which is apt, as Dezz specializes in creating highly realistic tattoos.

down-to-earth and usually enjoy routines and the stability of the physical world around them. They experience fulfillment through physical expression because this is their energetic language. For some, materialism refers to possessions and physical comforts.

For red-dominated auras, however, materialism is simply a neutral description of a belief that nothing exists beyond the physical plane. That said, some reds can be quite shallow, using their physical acquisitions— money, possessions, and social status—to echo their ego values. They can be aggressive, stubborn, short-tempered, and selfish. They may also eat and drink too much and rely on other physical pleasures to numb themselves against any unwanted reality.

Reds are the least New Age–oriented of all the people I photograph. Insofar as red is the color of materialism, it's also rooted in reality, which may be why it's associated with both the skeptic and the first chakra. Some people can express this energy for a week as if going through a phase, others for a lifetime.

Ever since our primordial awareness of red, we've associated the color with blood. Two themes have consistently coincided with this association: birth and war. Incredibly enough, the subjects I've photographed with all red often closely identify with these themes, with "birth" being a rebirth of some kind like a breakup, a new relationship, home, career, and so on. "War," in this case, usually doesn't represent anger, although perhaps some frustration. Anger is a shortsighted view of red; in this context, red represents a

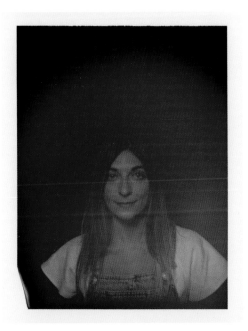
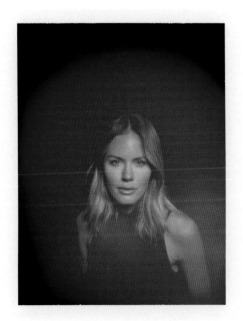
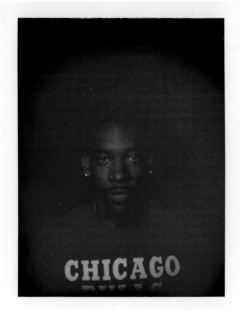
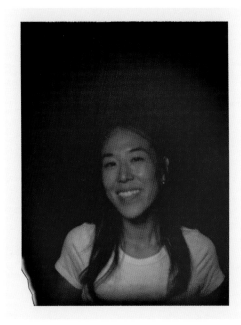

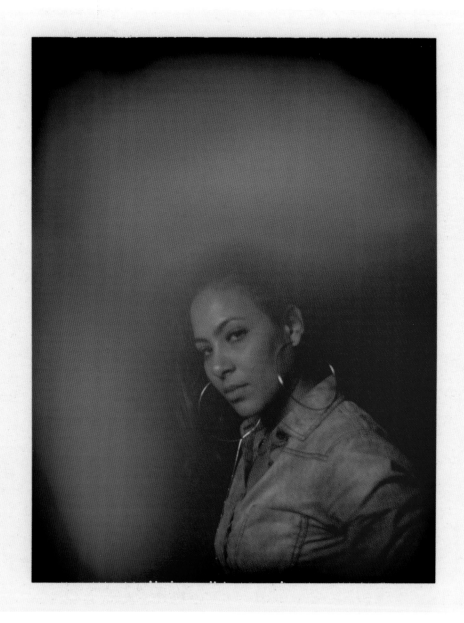

situation or series of situations that, like war, calls on a person's character traits—courage, survival, stamina, leadership, and willpower—to rise up and meet the challenge or the call to action. As Dr. Brené Brown noted in her TED Talk "The Power of Vulnerability," it's the sense of vulnerability and risk associated with the action of stepping into the arena that gives us true courage and the opportunity to live life wholeheartedly. In my experience, the majority of the people photographing with red are exactly the same people Dr. Brown is talking about. Ironically, red is an energetic tone that typically doesn't risk something unless it absolutely has to; but when it does, it's game on. So, while red can exemplify character traits we associate with getting things done, it's also about putting yourself out there and being willing to take the hits that come with thinking big and dealing with real-world fallout. Red is a force of will.

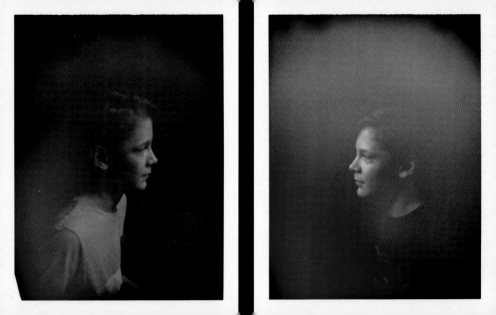

TWINS
Billy and Felix

Meet Billy and Felix. They're identical twins. Most identical twins photograph with similar colors.

Yet, upon first glance, they couldn't be more different from one another. On closer evaluation, however, you can see they're more alike than not. Use your hand and cover up the top portion of both photographs so only the lower corners are seen. Now look at the lower left-hand corner of the photographs. Both are red, a color I commonly see among young people, especially boys. This color represents new beginnings and survival instinct, which encapsulates the tween age perfectly.

When looking at the lower right-hand corner of the photographs, you can see that both boys have little to no energy, indicating that they might be shy or guarded, or stepping into a new phase of their life. The only area of difference is in the area above their heads—the mental field. These boys may act similarly, and internally they're going through comparable stages, but they think very differently from each other.

It's a common mistake to think that the mental area is what energetically dominates the aura. I have found that each area contains equally important information. You can still go through a red experience without having a photograph be all red, as these two photographs illustrate.

83

Identical twins almost always photograph with the same colorations. Sometimes they have the same colors in the lower corners but fluctuations in the mental area like Billy and Felix (opposite), while others are an exact match like Miryam and Sarai (pages 84-85).

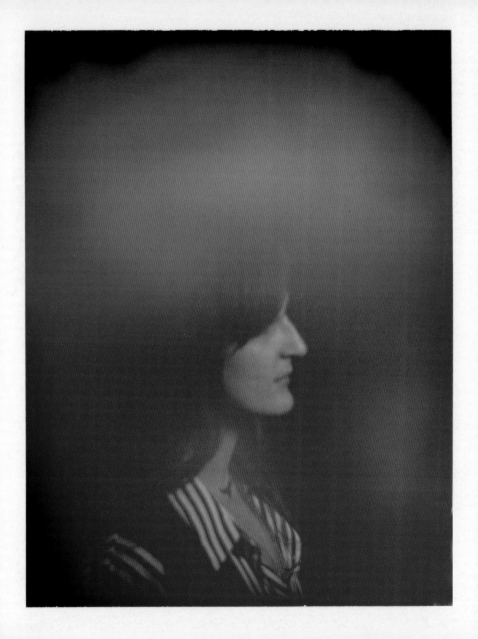

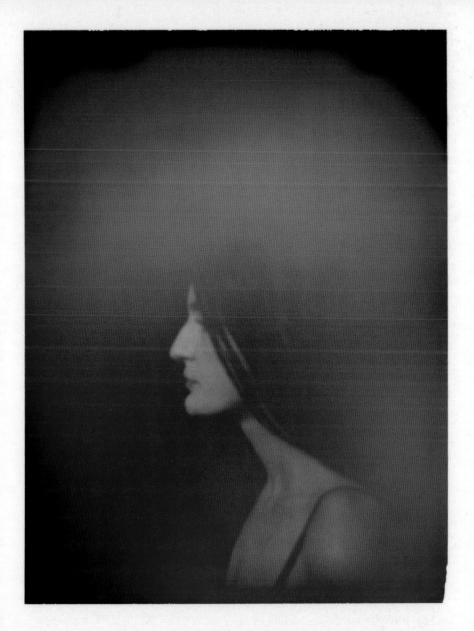

SHADES OF RED,
FROM MUDDY TO RUBY

Energy and color are fluid; it's common to have subtle shifts in tones and hues even within the same photograph. A dark muddy red often means a person has low energy, is physically exhausted or overworked—this isn't necessarily bad. People undergoing a change in their living space, such as remodeling their home, often display a lot of dark muddy red or maroon. Generally for most colors, the brighter or cleaner the hue, the more energetically healthy or robust the energy of the subject is. Depending on where the color presents itself on the distribution map, a dark or dampened shade may indicate mental, emotional, or social fatigue, whereas a bright, vibrantly colored shade, like a ruby red, may indicate a state of mental, internal, or external strength.

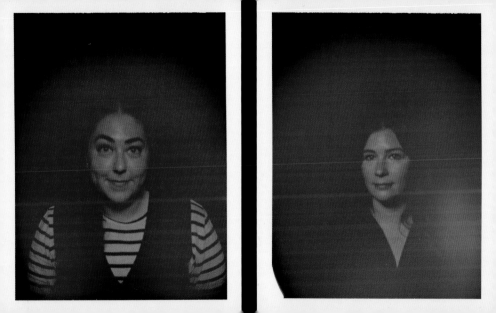

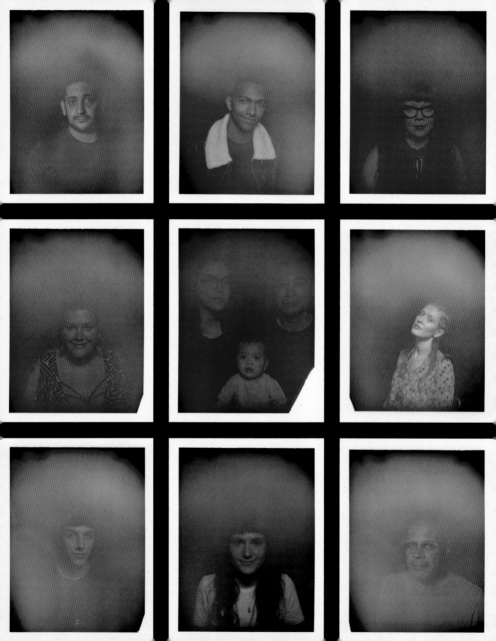

CHAPTER III
ORANGE

Orange began its life as the globular, juicy fruit before becoming the name for the color of the object it first described—*narang* in Persian; *naranja* in Spanish; *orange* in French; *orange* in English. Prior to the sixteenth century, the color was referred to as *geoluread* or "yellow-red" in Old English. It's this unique yellow-and-red combination that sets orange apart from all the other colors on the spectrum yet simultaneously puts it in danger of being misunderstood as a lesser tonal cousin. Some darker shades can veer on the side of brown, further complicating an otherwise sunny and dynamic hue.

Like its tonal companion red, orange is a bold color that quickens the pulse, signaling danger or excitement, sometimes both. Ancient Egyptians decorated their tombs with an orangish hue made from the mineral realgar, while the Romans used a similar pigment, made from realgar or a related mineral, on everything from manuscripts to portrait paintings. In India and China and in much of the Eastern world, the color is highly revered and is said to reflect the power of perfection. Known also as saffron—in deference to the orange-colored tip of the saffron crocus thread from which the spice of the same name is derived—the color is considered holy by Buddhists and Hindus alike. Vibrationally, orange relates to the sacral chakra, Svadhisthana, the energy center that governs creativity and sexuality.

Individuals with an orange-dominated aura do tend to be artistically creative, but they're also highly adaptable, creative problem solvers who can source solutions to just about every problem under the sun. While red-dominated auras need to summon up the courage to face difficulty, orange types are naturally fearless. They typically possess enough confidence to be able to move outside their comfort zone to make something

happen. It's this adaptability that primarily makes orange an energetic tone like no other and signals an individual who can effectively deal with a variety of people, places, and things; who, in fact, thrives on being collaborative and turning the everyday into an adventure. Parents of young children often photograph with a significant amount of orange in their energetic makeup, which isn't surprising given that parents rely on skills like adaptability, collaboration, and creativity when dealing with their kids. These are people skilled in diplomacy and solving problems on short notice.

Largely unafraid of the unknown, orange types tend to be explorers—they're travelers and risk-takers—who are at ease in new and unfamiliar surroundings and, blessed with their adaptable nature, are especially skilled at working with different personality types and navigating complex corporate hierarchies, which is why they usually excel in any position involving sales, client relations, or production. Think of orange as being the energetic equivalent to the smart kid in class who needs a healthy dose of challenges in order to stay engaged and avoid boredom, which can lead to procrastination or, worse, self-sabotage and destruction.

The key word here is "variety": orange types need it to stay stimulated, which may be one of the reasons why people I photograph with this color tend to be freelancers and entrepreneurs, or, if they have a boss, that boss has the good sense to give them enough freedom to have a feeling of autonomy in their work schedules. A micromanager or an overbearing boss tends to be toxic for an orange type. This is an energy type that finds fulfillment in being independent, expressive, expansive, and going above and beyond what they've previously accomplished. For orange-dominated personalities, life is about what you make of it, the fruit ripe for the taking.

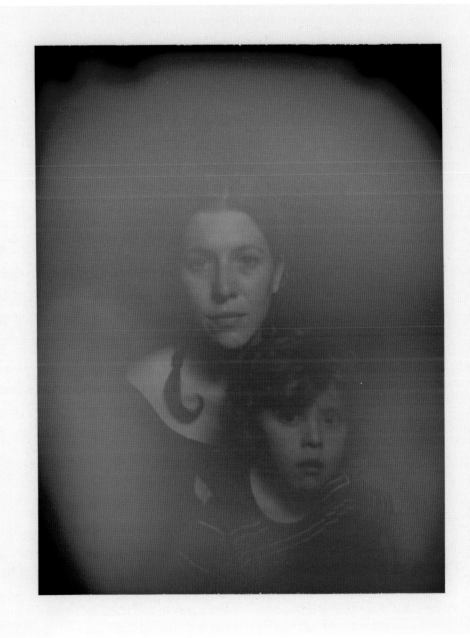

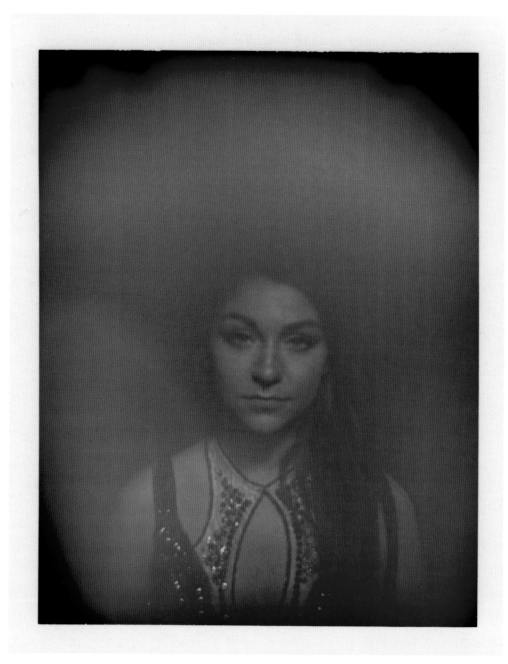

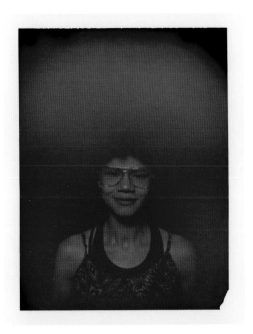
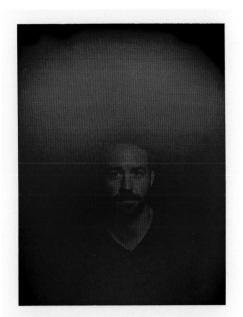
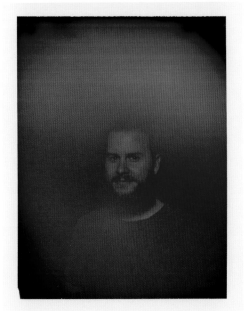

ORANGE-RED

A person with the dynamic of orange-red may feel caught between two worlds. On the one hand, this person values stability and practicality (red) and, on the other, requires a certain level of spontaneity and variety (orange). Red is quite a heavy experience, either dealing with a serious situation or being a serious person, whereas orange rolls with the punches and thrives on challenge. If this sounds confusing—it is. Most of the people I photograph with an orange-red combination are startled to find that it succinctly summarizes a complex and confusing dynamic that they themselves are most likely still trying to figure out. Depending on where these people are in their personal development, and if this dynamic is common for them, they could be more "at home" with this energetic dynamic than others. If red is in the lower left area of the distribution map and there's orange everywhere else, chances are they feel more of the challenges internally and can be a bit resentful or frustrated that they're feeling weighed down. Or, if they don't identify with having challenges in their life, then they're most likely dealing with the dichotomy of having an internal value of stability, practicality, and routine, while either having a career, aspiration, or social life that demands much more adaptability, creativity, and collaborative skills.

If the colorway is reversed, with orange in the lower left area of the distribution map and red everywhere else, chances are this person is breaking free of something, taking a risk of some sort. In this case, red reflects new beginnings, willpower, and the courage necessary to accomplish such a breakthrough. If this doesn't resonate, perhaps this person has

a desire to live every day as it comes (orange), while red represents the reality of a life circumstance that requires more stability and routine.

If these colors are either blended together or stacked on top of each other in a gradient, it represents this person's attempt at either balancing these traits or characteristics or simply embodying them as a synergistic quirk. If the color is bright in hue, this person just has more tools in their toolbox: they may be practical and reliable, yet nimble enough to adapt to a change of plans. If the colors are out of balance or reflect the negative qualities in a darker hue with some bruising, these people may be in a tough situation where they are being self-centered and reactive.

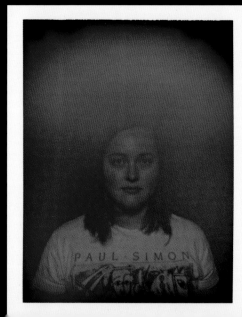

ORANGE-RED-TAN

The orange-red-tan dynamic shares many of the same attributes as red-orange, but the addition of tan indicates a tendency toward perfectionism, anxiety, and a strong need for detail. These people are either in a situation that demands them to fuse together three complex characteristics or, if blended, they have a natural ability to do so. They need to feel grounded and are adaptable and logical. If tan is found in the area above the head, the person is most likely going through a situation in the present that requires them to be a linear thinker or needs them to apply a structure or timeline to something—wedding planners or accountants preparing taxes, for example, may show this combination. If tan is found in the lower left area of the distribution map, it usually represents someone who values a sense of security, but, depending on the color combination, it can either be harmonious or dualistic.

If tan is in a gradient with red, this person enjoys being in the present and having instant gratification yet also sees the value of planning for the future. If tan is gradated with orange, it may indicate a need to balance spontaneity and a sense of order. It's not uncommon for a person with an orange-red-tan combination to vacillate between having a freelance career and trying to secure more reliable work from a steady employer.

If this same color dynamic is in the lower right-hand corner of the distribution map, it usually speaks more to this person's unique style of behavior—impulsive and direct yet calculated with a tendency toward perfectionism. This can be just as confusing for them as it is for others.

If red and tan are blended in the lower right-hand corner of the distribution map, it usually indicates someone who puts an emphasis on both process and results. If all three are blended in this position, this suggests someone who has a unique and quirky way about them. They need structure, but they like adventure, too, if what they're doing feels productive and yields a result.

Producers, teachers, and social workers often photograph with this aura because their work has many variables and levels of challenge that keep orange from getting bored, offers structure that satisfies tan's need for control, and overall engages red's need for tangible results. If this coloration checks all three boxes, this person will feel energetically fulfilled. If one or two of these colors are darker in hue, the person may feel just the opposite. Think of the main arteries in a body. If one is clogged or not functioning properly, it affects everything else. If a person hasn't found a healthy application for each energetic value, or has found it for only two out of three, that can put incredible stress on the system.

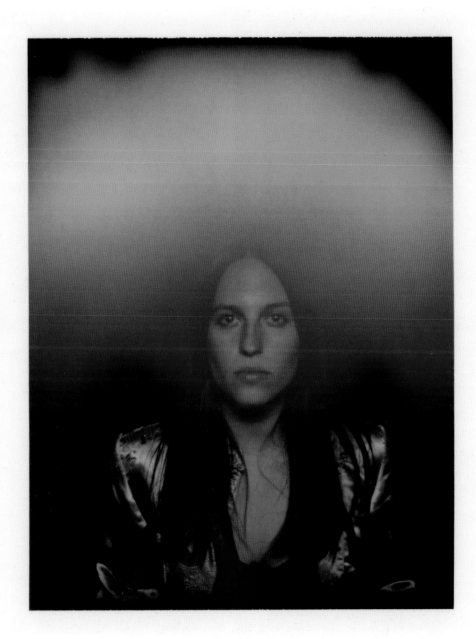

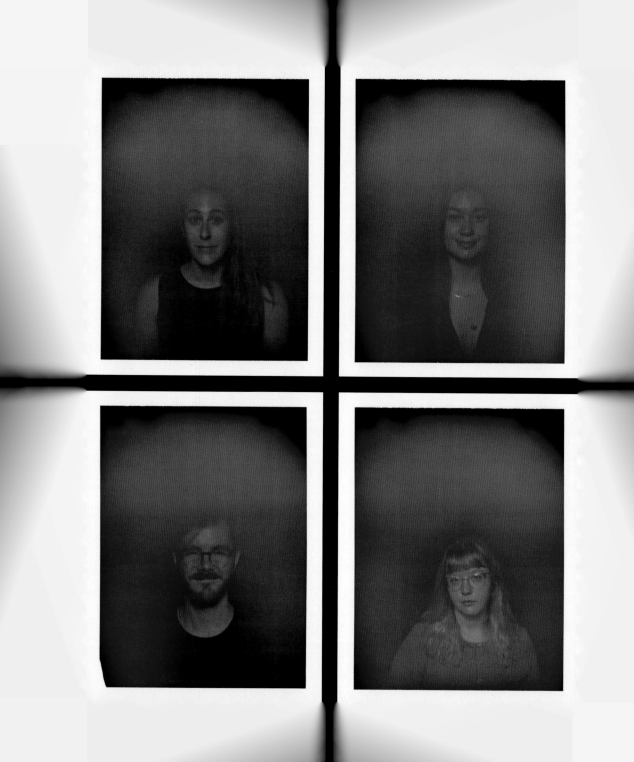

ORANGE-TAN

Certain color combinations consistently present in specific locations. When both colors are present as a gradient in one area, it indicates friction between the two personality types resulting in difficulty in making decisions on all levels—from deciding whether to call your secret high school crush or to quit a stable job to pursue a grand yet risky adventure. Orange-tan commonly appears as a gradient in the lower left-hand side of the distribution map, which indicates an internal negotiation of some sort between risk (orange) and security (tan). A tan personality often has a lot of concerns about control, security, and liability. Tan can be slightly anxious or Type A, doesn't like vulnerability, and has a hard time going with the flow. Orange is the opposite. This is someone who shoots from the hip and is creative, adaptable, and resourceful. Orange values the adrenaline that comes with having to work in the moment.

OPPOSITE, TOP LEFT: The orange-tan-green gradient in the lower left-hand corner indicates a person who is vacillating about a direction, weighing risk and security. **TOP RIGHT:** This blend in the mental area suggests a creative and adaptable thinker (orange) who is also logical and detail-oriented (tan). **BOTTOM, LEFT:** Orange and tan in the mental area suggests unique and avid interests; the external area indicates visible energy spent on attending to details (tan) and voicing opinions (green)—a common coloration among critics and collectors with distinct specialties. **BOTTOM RIGHT:** The orange-tan blend in the internal area represents someone who values variety and stability equally. For each energy to feel validated, novelty and challenge (orange) and security and control (tan) need to play a part in this person's pursuits.

Both tan and orange are types that tend to procrastinate—albeit for very different reasons. Orange waits until the very last minute to complete something in order to feel the thrill of accomplishment or puts it off because the work that needs to be done is boring or emotionally difficult, whereas tan procrastinates because they overplan, overthink, and fear failure. By the time tan is ready to get down to business, this person has usually experienced decision fatigue and is too exhausted to take the first step.

OPPOSITE: The orange-tan band above the head suggests someone who is prioritizing discipline and detail (tan), and creativity and expansion (orange). These colors appear somewhat blended here, indicating a person who most likely manifests these traits seamlessly. You can also see the reinforcement of these colors in the lower left-hand corner.

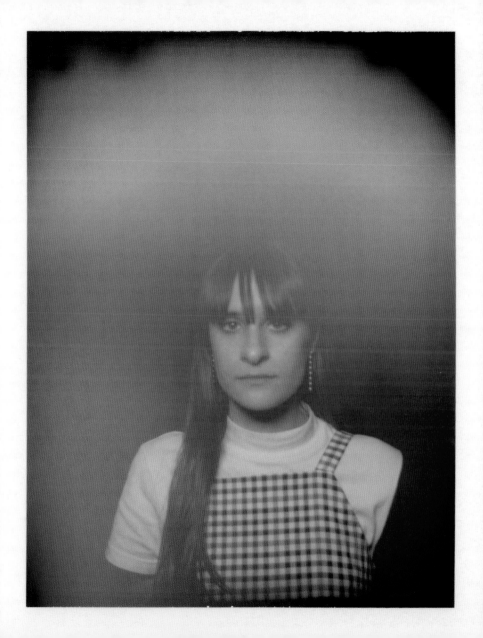

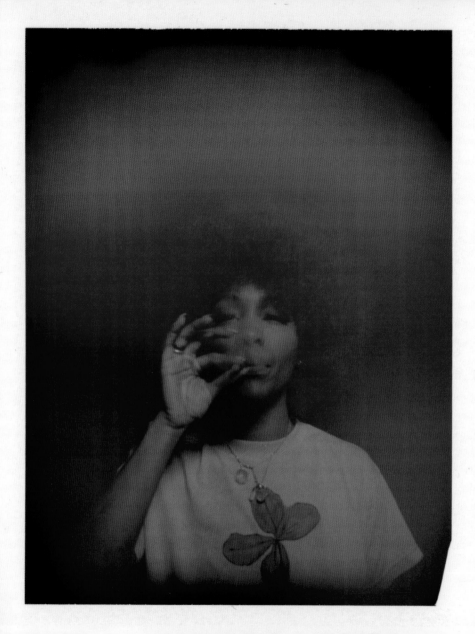

SZA

The complex band of two to three colors above the head indicates SZA is juggling priorities. Orange is typically a creative problem solver and is usually able to move beyond any obstacle. Red represents the need for stability and tangible results. Red shows up for life's challenges. In addition to the orange and red, I also see a small amount of tan, which, when in a band formation, typically represents the desire to control or mitigate risk in regard to the other colors in the band. Joined in the mental area of the distribution map is a gorgeous flush of magenta, illustrating SZA's unique and powerful artistic vision. This is a coloration that doesn't back down or compromise its individuality or creativity. The stubborn quality of this coloration is tempered by the soft cobalt blue of the lower left-hand corner, which indicates a well of emotional depth. The combination of these two colors suggests SZA is both an introvert and an extrovert: whereas blue can be sensitive and tends to take things personally, magenta prefers to brush this stuff off and not pay anyone else any mind. The lower right-hand side of the photograph is a shade comprised of blue, purple, and white. This combination indicates an energy type that's stimulated by a variety (white) of communities (blue) and visionary experiences (purple). Although SZA may lead with these interests, she's also quite sensitive (blue) and will require some downtime and close relationships to help ground her from feeling overstimulated.

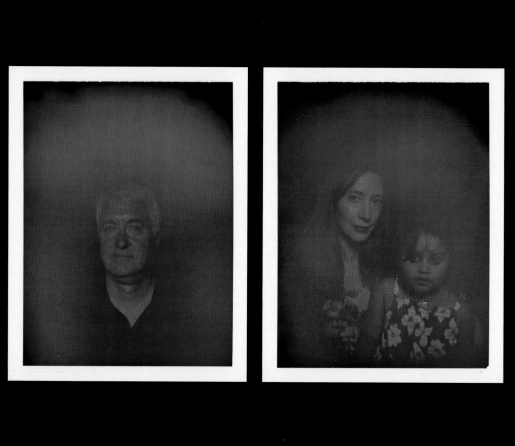

CHAPTER IV

TAN

As a shade of brown, tan doesn't show up on any simple color wheel, or even as a chakra, yet it's everywhere in daily life—from various woods to soil and clay. In the nineteenth century, tan was adopted as part of European military wear but mainly as a backdrop from which bright colors, like Prussian blue, could pop. Today, the color is most readily identified as the khaki color of business casual dress pants, which were themselves derived from military uniforms meant to allow soldiers to blend in with their natural surroundings. The correlation between tan and military wear resonates energetically in that tan happens to be the color most concerned with order and control.

While I have never photographed a wholly tan aura, the color does show up in interesting color combinations, and usually indicates someone who's in the process of energetic negotiation, be it mental or internal. Unsurprisingly, tan tends to exemplify a high-strung personality, someone with an excess of nervous energy, who therefore, like the roots of a tree, seeks stability and security over riotous and risky behavior. Tan is the color of adulthood, responsibility, and dependability. It remains steady and steadfast. Think

OPPOSITE, LEFT: Tan in the lower left-hand corner represents someone who values structure, control, and reliability. Coupled with the large amount of orange in the other areas, the individual pictured here is most likely an entrepreneur or someone in a vocation that requires diplomacy and adaptability as well as the ability to make their own rules. **RIGHT:** The gradient of tan and orange in the lower left-hand corner represents the duality of structure and fluidity, which is a common theme I see in parent-child relationships.

of tan as a supporting actor. In the drama of our lives, tan may be a trusty sidekick, a drill sergeant, or a nerdy next-door neighbor, depending on its location on the distribution map and the color it's gradated or blended with.

Of course, every color has an array of intensity and shading as reflected by an individual's energetic vibrations but, at its foundation, a tan aura usually indicates a taskmaster who values structure and wants a guarantee that everything is going to go as planned. This personality usually thrives on making lists and assesses success based on productivity and results. Whereas the lofty and dream-guided purple-dominated aura can move from step one to step fifty in the blink of an eye, a tan aura doesn't skip any steps out of fear of missing something. Tan finds comfort in the sense of control through analytics and process and believes there's a perceived order to doing things that's best to be followed, maintained, and honored.

Tan tends to procrastinate, but this isn't rooted in laziness. Tan is a tense, energetic color with a fear of failure, and this quality can exacerbate anxiety. Thankfully tan energy usually calms down when blended with another color. Orange, for example, has a calming effect on tan. Sometimes a person photographs with tan and reports having little to no anxiety. In these cases, tan is usually sharing space in the same distribution area

OPPOSITE: I call someone with this coloration a logical dreamer. This is someone who can be very concept driven (purple) and who can then apply that kind of conceptual thinking to a structure down to the smallest detail (tan).

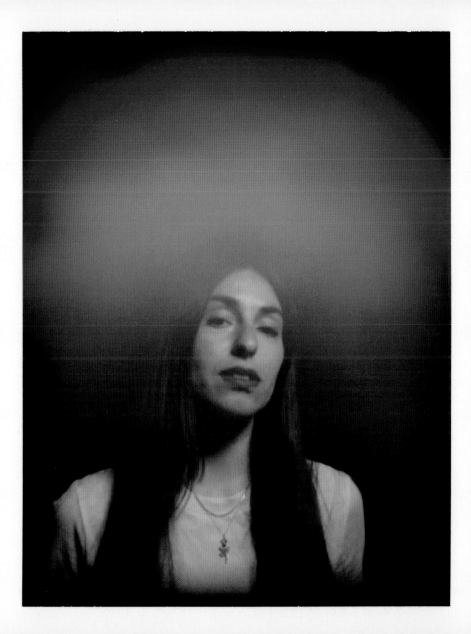

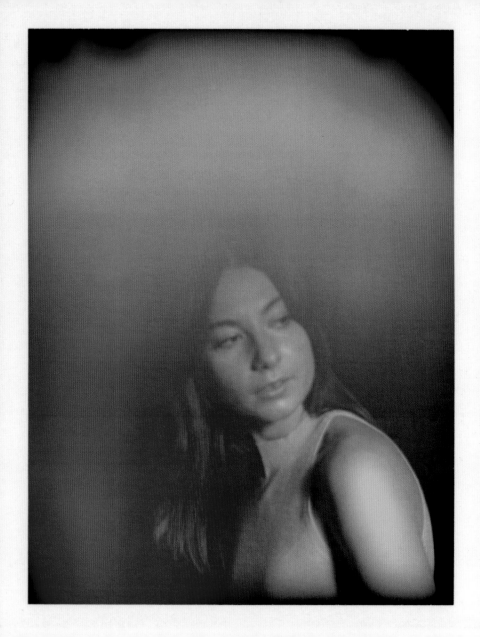

with another color and trying to find order in relation to the life area this other color represents. As an example, let's say purple and tan are in the mental area; this would indicate a mental state of taking a concept (purple) and coming up with a plan, order, or strategy (tan) to execute that idea. However, if tan were sharing the same space with green, this usually suggests someone who's focused on a goal or a long-term commitment (green) and is trying to identify steps (tan) to achieve it. If blue and tan share this space, it usually indicates someone who's feeling sensitive (blue) and is trying to manage their feelings and reduce the risk of expressing them in the wrong way.

OPPOSITE: Tan blended with orange in the mental area represents the ability to think creatively while also being attentive to detail.

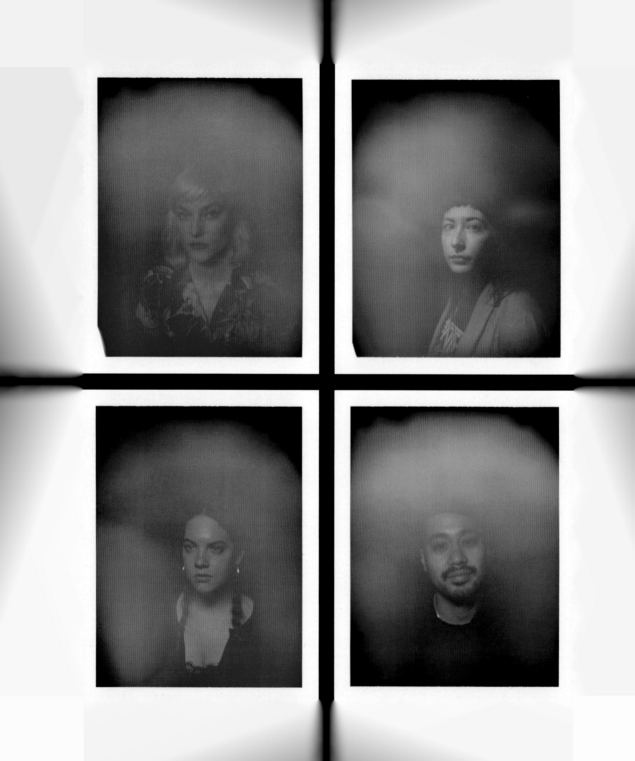

CHAPTER V
YELLOW

There are as many different shades of yellow as there are types of sunlight, with many cities—Naples, Tuscany, Paris, to name a few—claiming their provincial light as superior. As one of the most luminous of all the colors in the visible spectrum, yellow is truly eye-catching. In its metallic form, it assumes the quality of gold. People with a yellow-dominated aura certainly carry a gold standard of sorts: this color is commonly associated with positive emotional states likes happiness, freedom, and the sense of being carefree. (Think of the iconic yellow smiley face.) Like the sun itself, yellow-dominated auras radiate warmth and are graced with naturally high energy levels.

If aura colors had fanciful names, yellow would be Carpe Diem, representing spontaneity and lack of inhibition. Yellow auras spark joy in the everyday simply by their natural existence; theirs is truly an inner glow. As the color of the solar plexus chakra, yellow governs intellect, self-esteem, and personal power. This energy typically resonates with vibrations of mental activity, confidence, and the natural ability to motivate and energize others. While the color itself has expansive qualities, it's rare to photograph a pure yellow aura.

Yellow has never shown up alone in one of my photographs; it's always been coupled with another color, most often tan. The presence of tan (discipline, control) with yellow indicates a person who is constantly trying to balance what they perceive as seemingly incompatible characteristics.

OPPOSITE: I have never photographed a completely yellow aura. This sociable color always accompanies other colors, creating a complex, energetic dynamic.

If yellow is the sun, a bright optimistic energy, tan is the earth, a grounding influence that likes to-do lists and prefers logical thinking as the path to decision-making.

When yellow shows up in a gradient with tan—the color of discipline and restraint—it usually indicates the friction between two opposing realities or impulses: work versus play, spending versus saving, control versus flexibility. A yellow-tan blend usually represents someone who has a lot going on: they have an active, fun social life but also know that they need to get to bed on time, work diligently, and pay the bills.

Much like tan, though, yellow is usually found in combination with other colors. While tan is its most constant companion, yellow is often seen with orange, green, purple, and/or white. These combinations illustrate the work it takes to achieve an energetic balance among the complexities of our lives. Yellow, a "good time" color, isn't necessarily focused on anything in the long term—relationships, careers, and everything in between. Yellow is happiest when it is mentally engaged, but if the task or moment at hand is not interesting— like, reading something essential but not personally interesting, or needing to be patient while waiting for an outcome—forget it. In these instances, yellow energy is easy to spot: it's the first person to start fidgeting with their phone, scrolling for something fun to do while standing in a long line.

A person with a heavy dose of yellow energy likes to go out and enjoy themselves and spend money, even if it means they might overdraw their bank account. They may be reckless but are full of joy and are good at sharing it,

too. Being around yellow energy can be intoxicating. You can literally feel the sun on your face just by being with them. They are generous with their resources and have a here-today-gone-tomorrow attitude, but don't give your heart away to a yellow-dominated personality on the first night. These sunbeams don't like being tied down; it takes a special and unique relationship for them to invest in the long term. To be capable of monogamy, they need to stay interested, to find someone who "gets them" and not be asked to sacrifice their behavior for the sake of stability or, worse, someone else's emotional security. Yellows are best when they feel free from personal and societal expectations.

Unsurprisingly, yellows have a difficult time with confrontation and responsibility. They're generally loving people, but the moment emotional weight enters a conversation or a relationship (even if it's platonic), they get squeamish. Dealing with emotional repercussions, expectations, and someone else's insecurity makes them feel claustrophobic. Of course, this depends on where they are in their personal development, but most yellows would rather vanish into thin air than hear the words "we need to talk." Their sunny disposition, however, means that they don't take the harshness of life too seriously, and it doesn't take long for them to bounce back from confrontation, a trait that speaks to their overall easygoing nature.

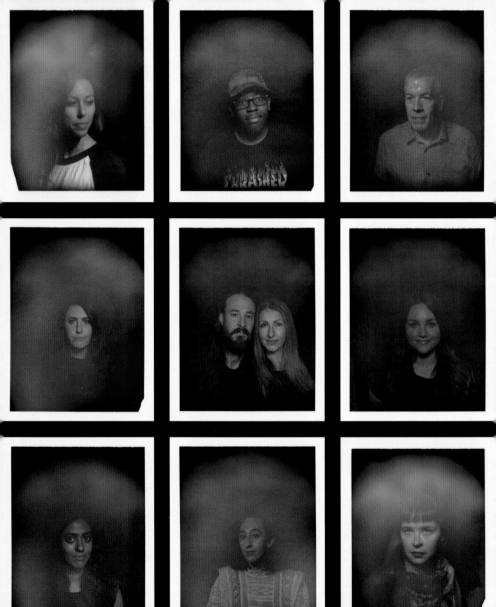

CHAPTER VI
GREEN

Contemporary color psychology associates green with growth and nature, but this is a relatively recent phenomenon; it has also been associated with greed, money, and poison. In fact, it wasn't until the Romantic period that the color became widely associated with nature and fertility despite the ancient Greeks, Romans, and Middle Eastern societies having long treated it as a sacred color. Green resonates with the vibrations of the heart chakra, Anahata, meaning "unhurt or unstruck." This chakra is associated with a sense of balance, calmness, and healing.

Green is one of the few colors I've encountered where the core qualities and definitions of the chakra system don't accurately sync up with the energetic motivations of the subjects I photograph. People who display this energetic color typically identify as someone for whom both growth and nature are important. A small percentage of people I've photographed have reported feeling balanced or calm, or identify as healers—though these qualities often accompany the sensation of being in nature or upon achieving a full state of mental or emotional growth.

I've come to view the green-dominated aura as one would a living, breathing plant searching for sun and water. The sheer energetic force even the smallest sprout musters to accomplish this task is staggering, yet natural. In this sense, green represents a kind of natural ambition. Think of a young vine racing up a trellis or leaves unfurling themselves in the sun. A yard left untended makes quick work of anything in its way, overtaking man-made structures and returning everything to its original,

vegetal state. Green pushes against life's obstacles and renders them obsolete. Similarly, a green-dominated aura perseveres as long as necessary to accomplish a task or a personal goal; this is a determined energy that accomplishes much. Unsurprisingly, such people are among the most critical energies, both of themselves and others.

Green auras can be impatient and stubborn. They don't let go of anything easily, preferring instead to hold tight or to bend an obstacle or challenge to their energetic will. Focused, driven, and goal-oriented, green-dominated auras don't perform well under vague conditions or direction. They value decisiveness and clarity and can become frustrated if they believe someone or something is wasting their time. They typically don't have a frivolous social life, instead preferring to invest their energy wisely in friendships, work, and romantic relationships where they have the greatest return on their investment.

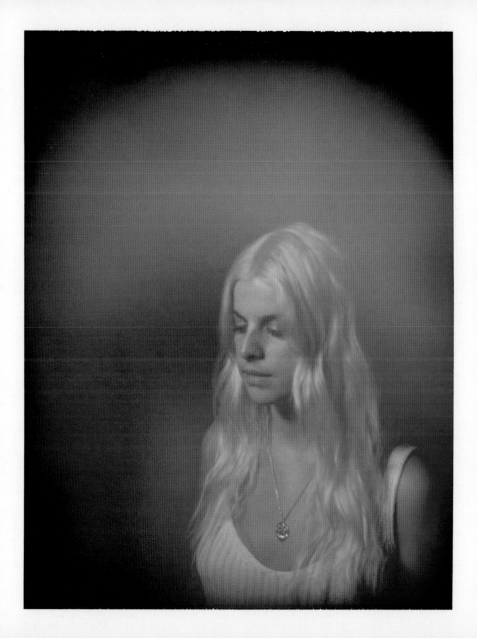

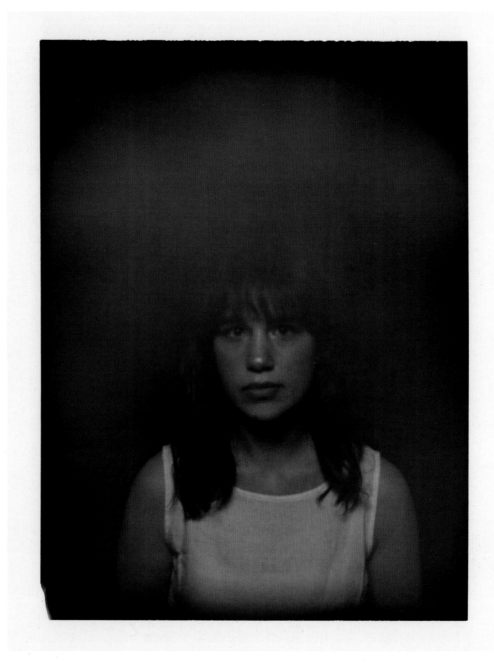

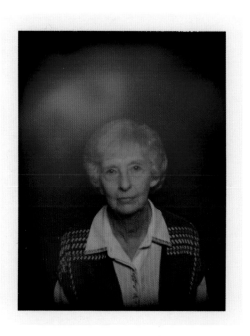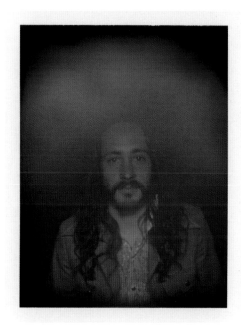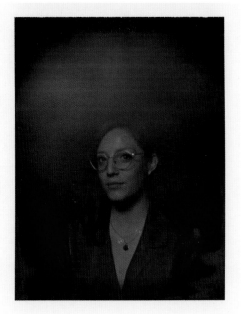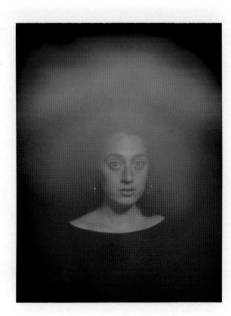

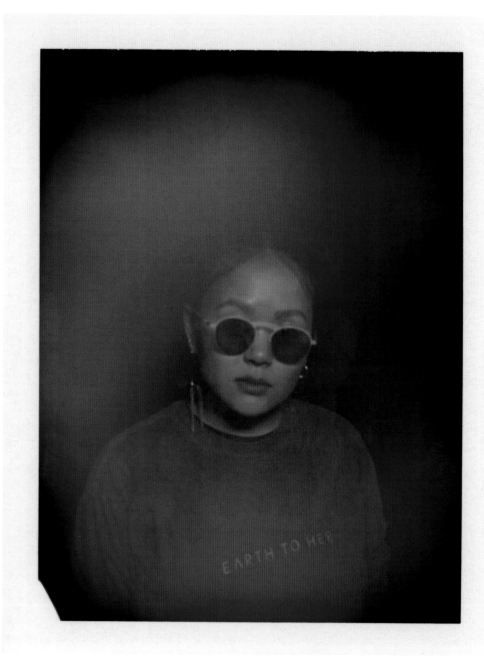

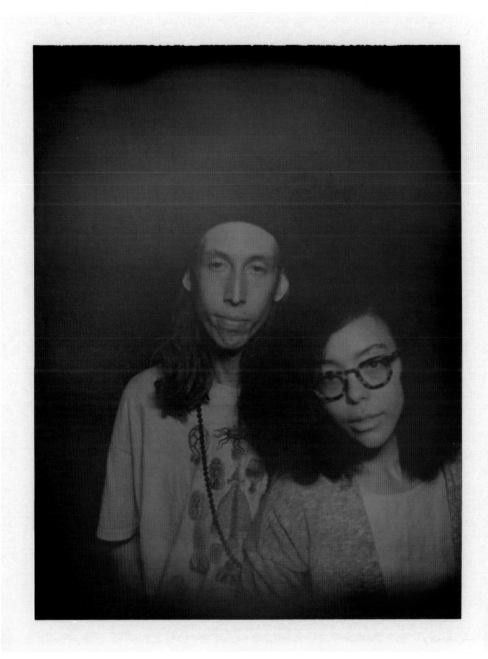

GREEN-TAN

Green is one of tan's closest allies; they both find value in being productive but usually rely on a different set of skills to attain their goals. Tan is a planner, but due to a tendency toward anxiety, they often subscribe to the attitude, "If you want something done right, do it yourself." Green likes to get things done, too, but can delegate and, in fact, is quite good at it because of a discerning nature and ability to see the long view.

That said, when a person has both colors in their aura, they are capable of being proficient leaders, as the tan component may provide enough structure and order for the green energy to give direction in a way that supports a team rather than dominates them. The downside is that if a goal seems monumental or the pathway to accomplishment becomes blocked in some way, they may become exasperated, a result of tan's tendency toward anxiety and green's tendency toward impatience.

OPPOSITE: The most common location for the green-tan dynamic is around the ears, right on the cusp of the mental area and the two lower corners, indicating these subjects' inherent ability to put their mental energy to use in various aspects of their lives.

Meghan's images document her arduous journey through law school. Tan and green are present in both images here, but they vary in placement, hue, and color combination.

In the first image, both green and tan are present in the lower right-hand corner of the photograph as well as in the area above her head. Tan is detail-oriented, logical, and disciplined. Green has a long-term awareness and is goal-oriented and focused. When I see someone with both of these colors, it almost always means that they're working diligently toward a goal. The hue is bright, and the distribution of color is fluid, indicating that there's a lot of energy—and that it's moving around quite a bit. The fact that green and tan are located in both the mental and external areas of the photograph indicates that something is consuming

her mentally and that she's simultaneously putting forward significant external energy. This color combo isn't surprising for a law student two days before taking the LSAT.

When red appears as a big fireball in the center (heart) of the photograph, it almost always indicates stress. Luckily for Meghan, the presence of orange suggests that she has the confidence and the emotional resources to deal with it. She's likely in a situation where she must be creative with her limitations—something orange is good at. The lower left-hand corner of the photograph is a blend of blue-purple-white, an energetic state that finds extreme internal value in community and ideals.

Meghan's second photo was taken one month after the first. The overall hue of the photo is much darker, indicating a kind of emotional

passivity. The tan and green remain, but now residing in the lower left-hand corner and in the small space below her throat and above her heart. These colors appear as a blend and are darker in hue, suggesting that she's experiencing more of the negative characteristics of the combination of tan (anxiety) and green (impatience). She confirms this, saying, "I got my results from the LSAT that day, which was a big deal to me, and I didn't do as well as I wanted." The red fireball is still in the heart area, signaling the still ever-present stress. The dim green in the mental area indicates that she's feeling self-critical. The combination of blue and green in the same space means she's most likely going through a mental negotiation of emotion versus logic. There's a significant amount of blue in both the area above the head and in the lower right-hand corner of the photograph, which suggests that Meghan is both feeling sensitive about her surroundings and thinking about how she feels. (See page 149 for more on blue-green combinations).

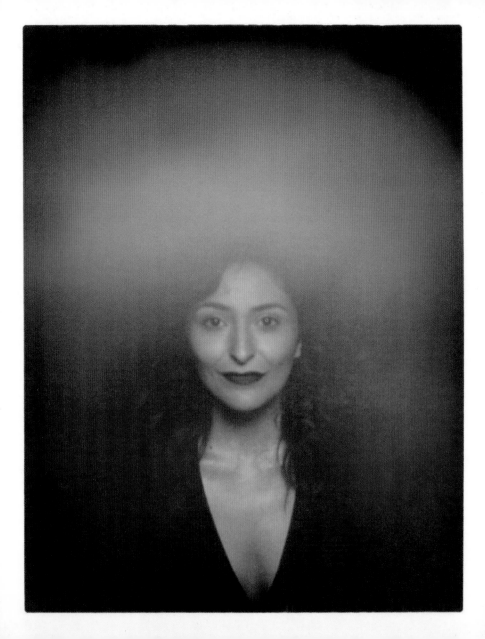

Though tan and green often show as gradients or blends in the same area, they sometimes appear separately, as in Gia's image. As a result, there's a subtle difference in how the subject displays these characteristics. The location of the color often dictates these subtleties. Gia has a combination that I call the "logical dreamer" on account of the purple and tan located in her mental area. The purple suggests that she's a visionary thinker, someone who likes to contemplate big-picture ideas and concepts—

subjects like philosophy and psychology, for example. The gradation to tan means she can apply theories of thought to a logical application, which makes sense as she was just about to start graduate work to become a therapist. The green here—which I often see in people who are in school for a long time—speaks to her diligence, focus, and drive toward achieving a long-term goal. Because green is in the external area of Gia's aura, this is what she is leading with; she's putting her future in the forefront.

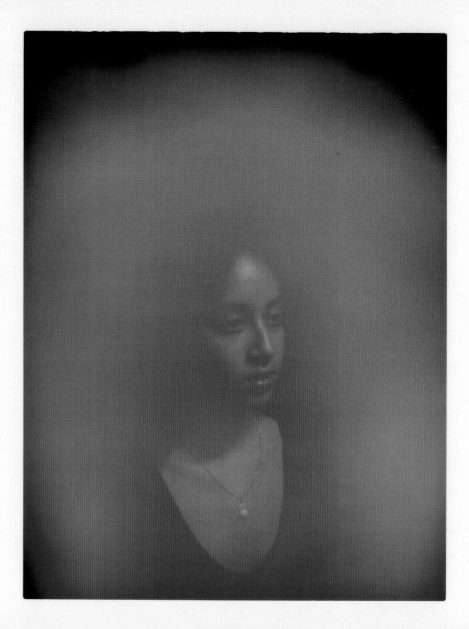

BALANCED AURA
Joana Mendez

Joana has a very balanced aura—one of the best I've ever seen. You can see that both lower corners of the photograph show the same seamless blend of orange, red, and just a touch of tan. Joana is both hardworking (red) and adventurous (orange), and possesses just enough logic (tan) to stay on track. The hue is clean and bright—and indicates she is feeling validation in these areas. The same healthy energy being held internally is also being expressed and actualized externally and rises up in the mental field—the area above her head. This indicates that Joana has fully synergized the energy in all areas of her life. The bright green band above her head suggests that she has a long-term goal of some sort that she's working toward, and its bright, healthy hue of growth-oriented green suggests that she probably feels like she is on the right path. The mental field also shows some yellow and tan. The fact that there's very little bruising among these colors indicates that she's been able to find a good balance among the conflicting values of yellow (freedom) and tan (discipline).

139

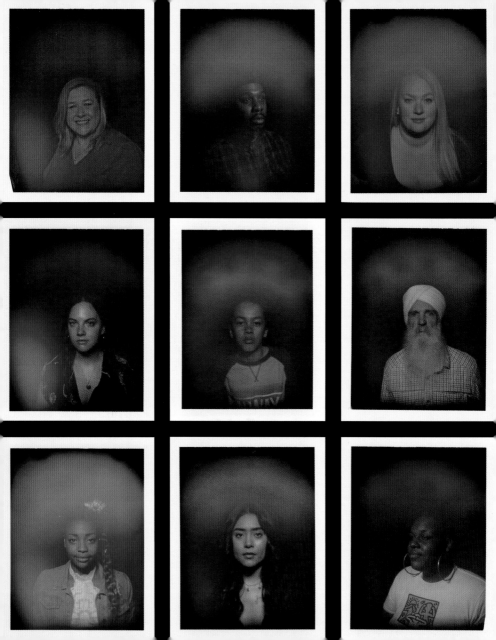

CHAPTER VII
BLUE

Hands down, blue is the Western world's color of choice; it also ranks high among Europeans. Western fashion, jeans notwithstanding, has been a champion of the shade for several decades. It wasn't always this way. For decades, blue didn't make the grade. It was particularly disliked by the ancient Greeks and the Romans due to its negative association with the barbarians. In the middle of the twelfth century, however, it gained traction, becoming a fashionable color, first in art—think of the Virgin Mary in her ultramarine-colored robes—and later in the royal courts and in everyday dress. Seen today as a kind of peacekeeping color—the United Nations' soldiers are referred to as "blue helmets" in Europe—the color certainly doesn't trigger the same kind of heated responses as, say, red.

Blue doesn't make waves; it is calm and peaceful. This energetic color type is deeply affected by their environments and by the company they keep. Their sensitivity is akin to having a strong sense of smell, but, instead, they have a strong sense of feel. Blue is the color that harmonizes with the throat chakra, which governs communication and sense of security. This corresponds to people with blue-dominated auras, who tend to be sensitive to their surroundings and others' needs. The energetic disposition of someone who photographs with blue is so connected to their environment

OPPOSITE, BOTTOM ROW, MIDDLE: Some blue can be very dark, verging on indigo. That's the case in the lower-left hand corner of this image, so when reading it, qualities of both energies may be applicable.

they can feel a bad vibe from across the room. People with this disposition may have to go to great lengths, like wearing noise-canceling headphones and keeping office doors closed, to be able to focus. This kind of heightened sensitivity, when healthy, acts as energetic glue, helping to bind the awareness and various needs of an entire family, a network of friends, or a team, into a seamless whole. If left unregulated, however, blue energy can be too much: codependency can be an issue.

Because this is an energetic tone that thrives on feeling harmonious, blue-dominated auras tend to prioritize tranquility above all else, including their own needs. As such, they choose their battles carefully—confrontation and misunderstanding come at a much greater energetic cost to a blue-dominated aura than to any other energetic type. It's simple: a blue energetic tone feels everything a bit more, for better and for worse. The blues itself is an entire musical genre based on emotional doldrums. As blues guitarist Otis Rush once said, "Nobody can tell you how the blues feel unless they have the blues. We all take it differently."

Blue is also interpreted as being a service-oriented color—think of the honor-bound naval men and women around the world—and this idea bears out energetically, too. Blue energy values trust, loyalty, relationships, connection, and community. Blue, perhaps more than any other color on the spectrum, uniquely symbolizes both communication and connection. If blue shows up in a photograph, I immediately search for compounding colors to point the way toward an overall energy dynamic because blue

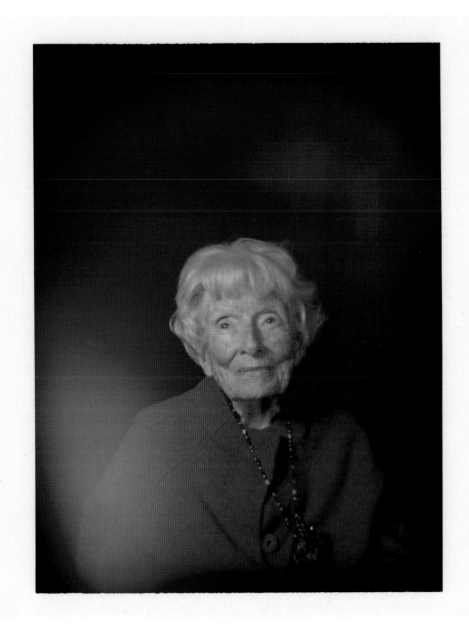

thrives to connect with other energy. I rarely see blue alone. Instead, it usually appears in one of three different color combinations: blue-purple; blue-green; or blue-purple-green.

The combination of blue and purple usually indicates an energetic tone that needs to feel connected to an ideal or wants to connect with an inspiring, creative community (purple). A blue-and-green combination usually indicates tension or a give-and-take between competing drives, like emotion and logic. A blue-purple-green combination signifies a moment in time when someone is processing how they feel (blue) about an idea (purple) and how to move forward (green). The connotations can change depending on where the colors show on the distribution map.

OPPOSITE: In 2015, I had the remarkable opportunity to photograph several gang members in San Diego called the Sherman Boys. For the majority, their auras consisted of reds and blues. The photo included here is of Amer, not an official member, but still included in the group. After photographing him, we spoke about what the color blue represented. When I mentioned the word "family" in connection with the color, he revealed that he was thinking of his sister, who had recently died. PAGES 146-147: When a parent and child are photographed together, blue is commonly present, an expression of the sensitivity of the relationship. I also see orange a lot in parent-child portraits, and it indicates a diplomatic, creative approach to problem solving.

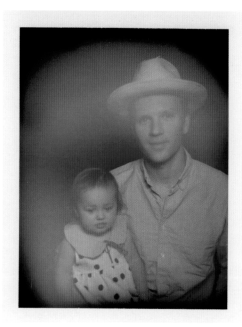

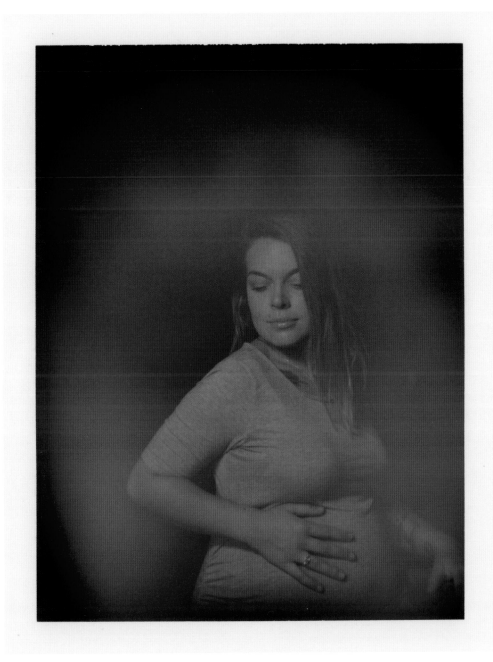

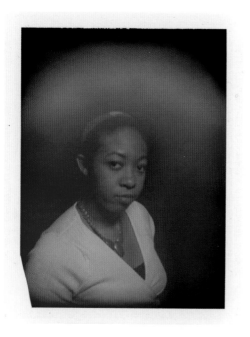
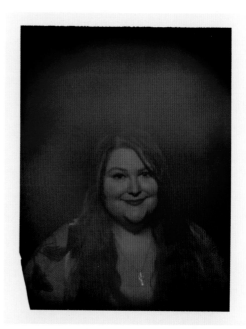
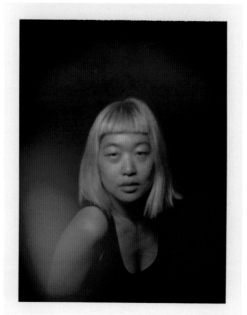
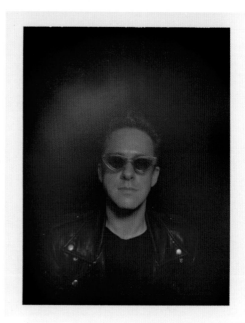

BLUE-GREEN

When blue and green are both present in the same area, it usually creates tension. Blue is a nurturer, someone who either naturally prioritizes a sense of harmony with others over their own needs or is in a situation where they feel the need to do so. Green is usually more focused on their own goals, generally preferring clarity, direction, and efficiency to the complexity of emotions. When the two colors are side by side in the same area of the distribution map, it suggests that there's a negotiation of some kind, most commonly between home and career, emotion and logic, or giving versus taking.

When the colors are blended with each other (and not side by side), they become synthesized. No longer in opposition, they typically indicate someone who is intuitively feeling out (blue) a specific direction (green). Subjects with a blended blue-green typically say they feel they're searching for something or trying to come to terms with the direction of a relationship, career or home move, or an obligation.

OPPOSITE, TOP LEFT: A blue-green gradient in the external area represents someone who has to balance their outgoing energy between dedicating their time to others and their own goals. **TOP RIGHT:** A person with a green interior energy is one who has high standards for themselves. Validation comes from feeling on track or on the right path. With blue in the lower right-hand corner, this person may find it difficult to decide how they spend their time. **BOTTOM RIGHT:** A blue-green gradient in the mental area reflects a negotiation between two values. When this photo was taken, Max was trying to decide whether to make a lifestyle change and move from New York City to Los Angeles. **BOTTOM LEFT:** A blended blue-green in the mental area indicates an intuitive mental process regarding a direction or path.

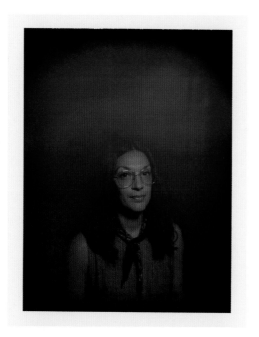
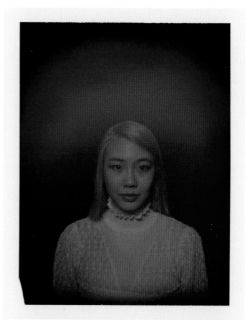
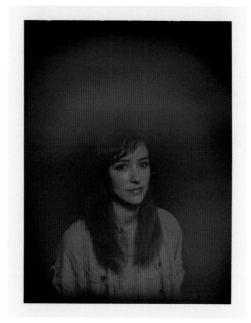
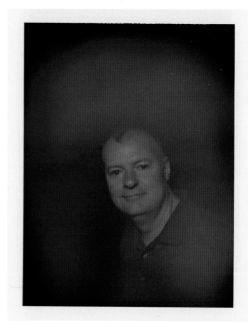

BLUE-PURPLE

Blue-purple represents the classic ambivert—that is, the combination of an introvert and extrovert—and illustrates an energetic state that derives a sense of validation from a shared concept, vision, or state of intellectual or creative inspiration. People with this energy have a need to share their vision as well as the need to belong to a family, relationship, or community through that vision. Lots of performers, fashion designers, and celebrities have aspects of blue and purple, preferring to take the spotlight only when it's been defined by them. When not on stage, however, this energetic personality strives to lead a private life; values trust, loyalty, and community; and seeks out like-minded people.

Of course, plenty of regular folks have this combination, too. Once this personality is surrounded with a group of trustworthy, loyal friends or is in an environment where they feel comfortable and safe, they can open up to the spotlight, sharing themselves freely and turning on the charm; otherwise, they can be content to simply step back and observe.

Visual Diary

KATE AND PETER SCHWEITZER

The Energetic Dynamics of a Couple

When photographing a couple, I give each person a hand sensor, so the electrodermal readings from the left-hand sensor captures the energy of one person and the right-hand sensor captures the other. There is a common misconception that the left side of the photograph is the left person and the right side is the right person, but keep in mind that the camera is only photographing the physical body, not the aura. The aura is essentially a double exposure of the energetic translation into color through the hand sensors, and since the camera doesn't know that it is reading two separate hands, this effectively tricks it into thinking it's photographing one person. The aura photo represents the energy of their coupling, not of each individual. The distribution map still applies, representing the duo as a complete entity.

I photographed Kate and Peter Schweitzer over the course of six consecutive years. Blue and purple remained consistent colors for them, although they shifted to different places on the distribution map and slightly changed hues. This kind of color consistency doesn't always happen for couples, but the Schweitzers are steadfast in their creativity and visionary thinking (purple), and their emotional bond (blue) is foundational. During the time that these photographs were taken, their marriage withstood career changes, adventure, trauma, and the hope of a new life. Their portraits offer an intimate glimpse into the energetic dynamics of a life entwined.

2014: BURNT OUT AND A NEW PROJECT

Peter and Kate reported that they had begun to work on a project together. The bright, almost neonlike magenta in the lower right-hand corner confirms this energetic drive toward an endeavor, even if it means depleting their reserves, suggested by the absence of color in the lower left-hand corner of the photograph. The rich shade of blue above their heads shows that they're sensitive thinkers and that their relationship benefits from a good amount of emotional intelligence. There's some green with the blue here, indicating that they are most likely trying to balance many obligations.

ABOVE: "Kate was burnt out after years of teaching at a demanding school and left work to find a new direction in life. I continued my day job working as an engineer and pursued my passion—photography. We began photographing a cookbook together for a mutual friend. . . . Our lives were busy, and we poured much of our energy into projects and community."
—Peter Schweitzer, 2014

2015: CREATIVE RISK

In this second photograph, purple is still a constant. This time, it's in the lower left-hand corner, which indicates an embodiment of their creative vision. The area above their heads has changed from blue and green to orange, which is in line with Peter's decision to transition from his full-time job to work as a freelance photographer. Orange, in this sense, represents that creative risk and the influx of social engagements. Their overall energy is bright and strong. The lightness of the lower right-hand corner suggests they may be fatigued, but it's nothing too serious or heavy, as the overall quality of the hue is still bright.

OPPOSITE: "We had just celebrated our seven-year wedding anniversary and were feeling really good about where we were headed. We were building a strong community of friends, both in Portland and around the country. Our house and guest room were always full as friends made their way through town." —Peter, 2015

2016: SEEING THE WORLD

This photo was taken after a year of traveling, exploring the West Coast, spending Día de los Muertos in Mexico City, driving the circumference of Ireland, and seeing Norway in the winter while working together on an art project. This is the second year in a row that we see purple and vibrant orange—a perfect combination to illustrate two creative people in love traveling the world together. For the Schweitzers, the muddy red in the lower right-hand corner indicates fatigue and is probably due to them traveling all year.

2017: COMPLICATIONS

While there's a healthy blue in the lower left-hand corner, indicating a strong emotional bond, when compared to the earlier photos there's also a heaviness to the hue, both in the lower left-hand corner and in the space above their heads. I'm neither a doctor nor a healer, but I've observed a consistency of this coloration among people who experience chronic fatigue or some type of energetic deficiency. Peter confirmed that Kate had been struggling with a yet undiagnosed ailment.

OPPOSITE, LEFT: Purple and orange share space above the head, along with a bit of white, indicating the intensity of their traveling experience. This combination shows that not only have Kate and Peter been able to mentally connect with one another, but they've also been able to do so in a way that's empowered them both to be adaptable, collaborative, visionary, and adventurous. **RIGHT:** In 2017, Peter reported, "Behind the scenes, Kate had been getting increasingly sick without any clear answers."

2018: A SAFE HAVEN

The next time I saw the Schweitzers,
in March 2018, the muddy dusty rose
was replaced with a strong, relatively
clear purple. This suggests that they
were mentally empowered by a unified
vision; as it happened, Kate was only
recently diagnosed with a chronic
illness. The blue in the lower right-hand
corner speaks to them creating a safe
haven at home.

JANUARY 2019
A REMODELING

There was a significant energetic shift
the following year, as evidenced by the
presence of blue-green in the mental
area; this isn't too far off from the 2014
photo. This color combination usually
indicates a struggle for balance. The
lower right-hand corner of the image
is a faint dark purple, which indicates
that they may have felt uninspired or
disillusioned with the outside world.

OPPOSITE, LEFT: This portrait was taken only a month and a half after Kate was finally
diagnosed with a chronic illness. The colors in both the mental area and the lower right-hand
corner are clean and bright in hue, which shows me that, despite some internal heaviness,
their mental attitude is still unified in the same vision and they are still able to connect with
one another in the relationship. RIGHT: As the darkest photo in their series of six, the color
combination of blue-green and dark purple reflects a feeling of displacement due to a
remodeling of their home that, in Peter's words, left them both "drained."

AUGUST 2019
A NEW BEGINNING

When the Schweitzers saw me next, Kate was five months pregnant. There is a burst of purple in the center of their photo, which was new in terms of their portraits. This color typically shows up for people who have a dream (purple) that they're holding close to their heart, which makes sense with the news of Kate's pregnancy. There is also a lot of beautiful bright green, an all-systems-go green emblematic of go-getters and people on the move, anyone who thinks about the future. There is some bruising in the green, which indicates self-doubt—also normal for someone navigating pregnancy and chronic illness. There's also very faint color in both corners of the distribution areas, which shows us that all their energy has been allocated to their mental space. Clearly, this is a mentally consuming time for them.

OPPOSITE: White is nestled in the foreground of future-oriented green. White typically indicates overwhelm and is most likely representative of the flood of information that inundates any soon-to-be parent.

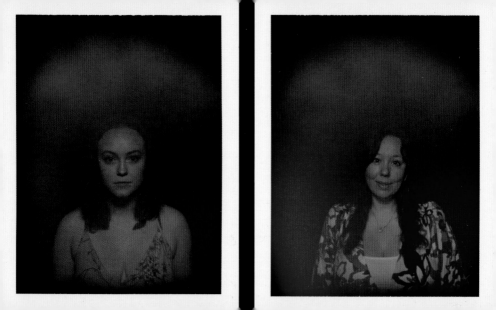

BLUE-GREEN-PURPLE

The dynamic of blue-green-purple usually presents itself in the area above the head on the distribution map, which indicates a state of mental processing about how someone feels (blue) about a certain direction or possible goal (green) and the idea or concept (purple) of the goal. Subjects with this combination commonly say they're in a state of transition, thinking a lot about the next steps in the course of a relationship, for example, or in their career, and either feel a little lost about what to do or are in the midst of a course correction. The color pattern frequently looks like a literal cloud above the subject's head, indicating a kind of mental/emotional storm they're weathering.

OPPOSITE: Dots above the head represent intense mental processing, a common occurrence in blue-green-purple mental dynamics.

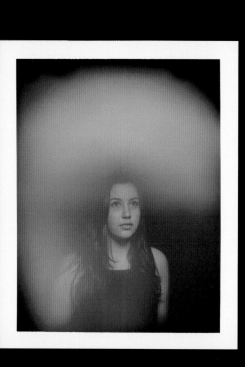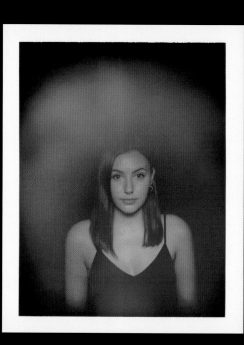

Visual Diary

CORRINA YANAGAWA

took the first aura photograph of Corrina in 2015 (opposite, left), when she had just started college. She didn't feel particularly excited about school, didn't know what she wanted to focus on in terms of her education, nor did she have an idea of what he wanted to do after college. As he said, she "wasn't looking to the uture much." There is a lot of white blended with purple in the lower ight-hand corner, an indication that he was inspired by a lot of things, but indecisive about what to pursue. There is also plenty of white blended n the dusty rose, which accentuates he uncertainty this color is known for. With blue as an external color, Corrina s likely a very sensitive and aware erson who would feel validated eing part of something.

In the second photo (2018), she had just graduated from college and was in another transitional point in her life—post-breakup and looking for a job. The color combination above her head indicates a mental negotiation of some sort (blue-green) and the mental processing of a strong belief or perspective (purple dots). The allocation of color is strongest on the left side of the photograph, which means she hasn't found the proper outlets for her energy. As she put it, "Almost everything in my life was uncertain: my relationship, my job, my future." The green correlates with her throwing herself into a job search. The blue in the lower right corner is remarkably consistent with her photo from three years before, and represents that, even among all this uncertainty, some things stay the same.

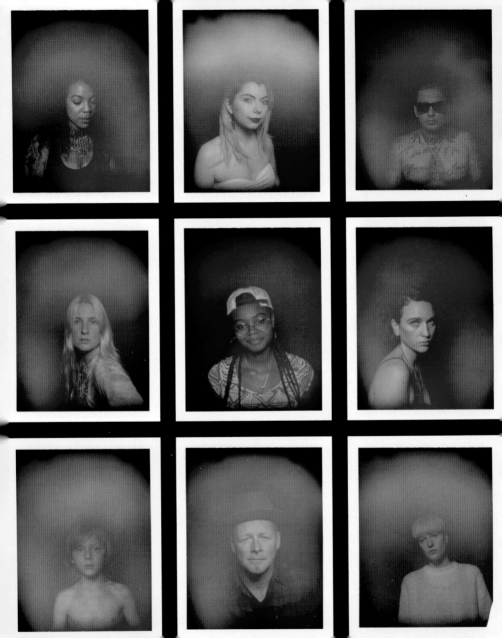

PURPLE

Technically speaking, the color purple isn't part of the visible color spectrum, although its sister shade, violet, is. When Isaac Newton identified the colors of the rainbow, purple didn't make the cut because it doesn't have its own wavelength of light and is only imagined by a trick of our eyes, further illustrating the idea that purple truly is the stuff of dreams. Between red and blue on the color wheel, purple is considered a secondary color.

Historically, the color has strong associations, especially in the Western world, where it was worn by those in power—the wealthy and the elite—and was also used to establish a connection with the spirit world. The Romans, for example, adored Tyrian purple, an expensive dye that yielded a deep hue and quickly became the color of opulence. The Romans famously cloaked newborn princes (and their nurseries) in the shade during the era of the Byzantine Empire: to be born in purple was to be royal. The Japanese also shared a kinship with the color: *murasaki* (deep purple) was reserved for use by members of the elite. While today just about anyone can wear the shade, it still hasn't shaken off some of our associations with it being a magical color connected to higher consciousness.

Many of the people I photograph say they want to photograph with a purple aura and have no qualms in confessing their hope the image will turn out that way. Somehow, they have the notion that purple is the "best" color, as if a hierarchy exists when color is associated with energy—it doesn't. When purple appears in a photograph, it usually indicates a

creative and open-minded individual, a nonconformist who loves to question and push past the status quo to find a new way of thinking about or doing something. Imagine Jimi Hendrix performing "Purple Haze" or Prince doing his thing with "Purple Rain": both performers were cultural revolutionaries who cared little for the mainstream. On the literary side, Alice Walker's Pulitzer Prize–winning novel *The Color Purple* also changed the cultural landscape and was a totem to the divine qualities of purple, with Walker writing, "I think it pisses God off if you walk by the color purple in a field somewhere and don't notice it."

Like Hendrix or Prince, or a field bursting with fragrant lavender, a person with a purple-dominated aura is charismatic and magnetic without necessarily being outgoing. A purple aura indicates a natural performer, someone who's comfortable being center stage as long as it's on their terms. Depending on the position of the color in the photograph and how it combines with other colors, they don't require the attention—it just happens naturally.

Although purples can be lighthearted and easygoing, they engage in a lot of dreamwork—the mental process of playing out different scenarios in your mind whether in the past, present, or future—as a means of developing new ideas, processing information, or determining individual beliefs and/or perspectives. Philosophers and psychologists do a lot of this kind of work. Because dreamwork has a visionary aspect to it, it usually shows up in an aura photograph as purple. If purple shows up in the area above the

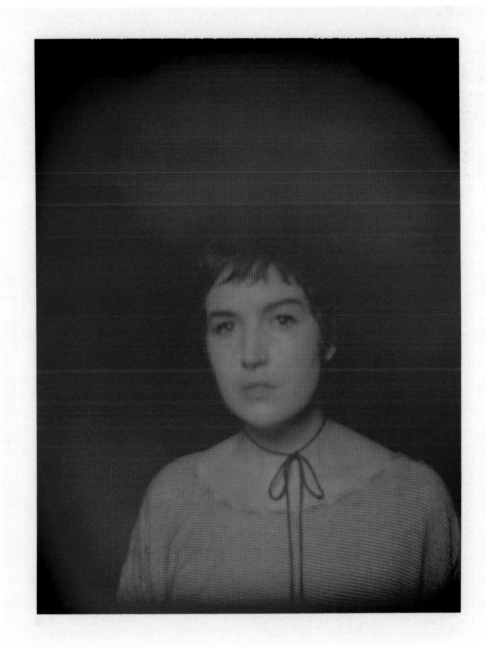

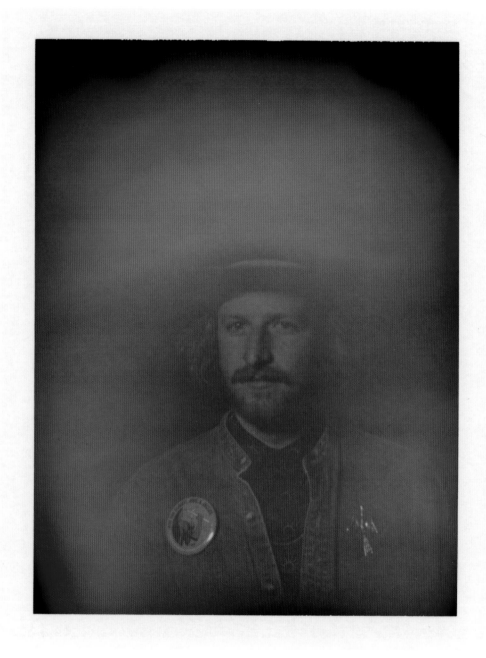

head on the distribution map, I look to the lower corners to gather more information. Not always, but more common than not, the presence of blue or red in these corners is a grounding influence and usually indicates that the person is less spacey and playful than a typical purple is. They may be facing a significant event on an emotional level (blue) or physical challenge of some kind (red) that involves leadership and tangible results, like starting a new project. In this instance, the purple above the head indicates a person who likes to play out scenarios mentally; whether they act on them depends on many variables, especially the color that sits in the external area of the distribution map.

A person with a dominant purple aura needs to draw on other energies present in the image to help center and manifest their aspirations and dreams. Tan can help guide the energy of a purple aura by countering its propensity for distraction with a sense of structure and detail. Yellow can be more playful and impulsive, red more serious and hardworking, green more discerning, and orange energies can help purple take more creative risks.

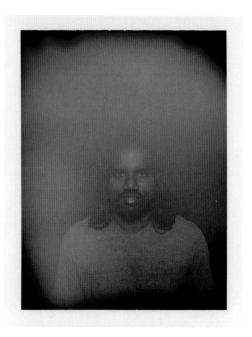
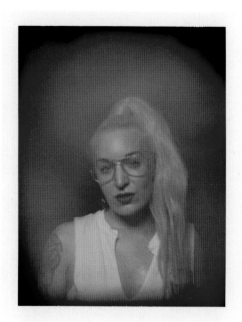
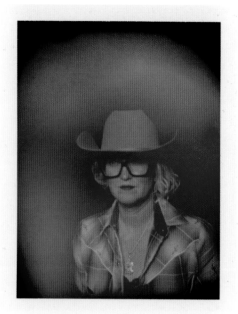
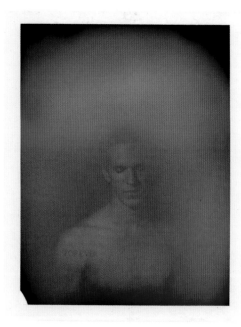

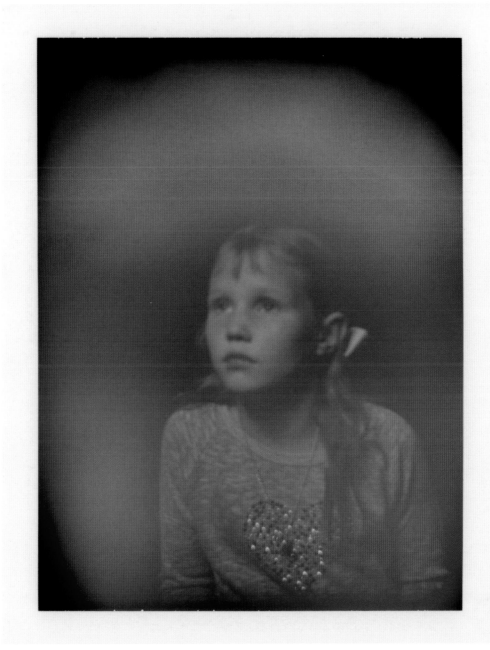

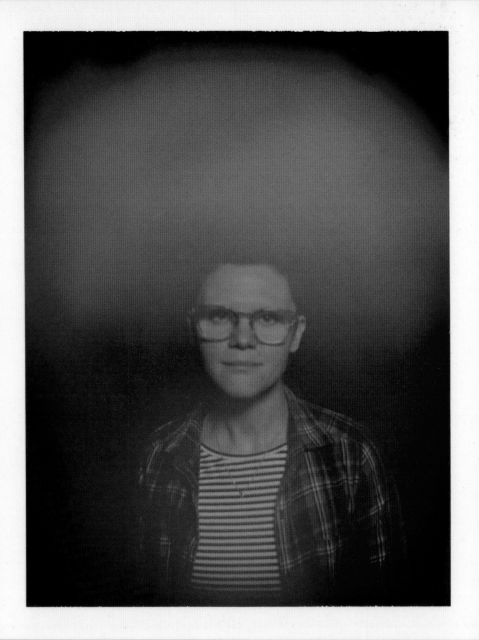

DREAMWORK WITH A BLUE INFLUENCE

Jeanie Larson

This case study of Jeanie Larson high-lights the dreamwork quality of purple and the influence an accompanying color—in her case, blue—has on the type of dream or ideal she was working toward or through. Blue-purples commonly have a sense of duty to care for loved ones and to live according to a particular belief or ideal, even if doing so comes at great personal cost. Blues are nurturing and sensitive and often have a hard time establishing boundaries with those they love; purples are compelled to live their lives according to concepts and ideals, often placing them before their own needs. Should they appear together in an aura image, specifically Jeanie's, you get someone who places family first. Jeanie confirms this, saying, "I was stable in my home life. Being a mom and a wife is nothing I thought I wanted but everything I have come to love. . . . I was actually very sad and depressed about my childhood and past in this photo. I was going through some huge life challenges with trauma that came up in my past, which I think manifested from having a baby and getting married. My body started to break down physically, and I was having a difficult time taking care of myself, not really knowing how to. And yet I still had this sense of duty to care for a toddler that sucked a lot of energy out of me; I really couldn't think about myself."

Jeanie's statement bears out energet-ically: first, in the dingy quality of color in the lower left-hand side of the distribu-tion map, which illustrates the depletion of self-care so common for new moms. The strong showing of blue in the lower right-hand corner indicates her deep sense of loyalty and nurturing tendencies to everyone but herself. The purple is most likely the result of all the dreamwork she was doing regarding her childhood and life challenges.

175

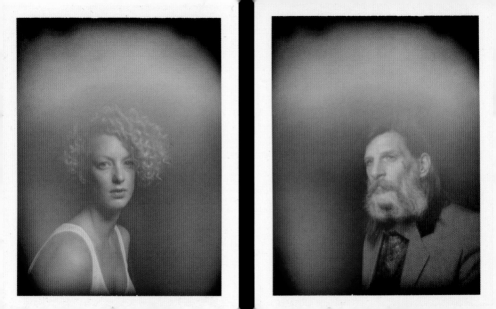

PURPLE-YELLOW-TAN

A gradient of purple-yellow-tan displayed as an arc above the head may signify that a person is mentally trying to balance several different priorities at once. Purple is all about concept and the big picture; tan is about logistics; and yellow is in the moment and free to be what it wants to be. The trio represents the near-constant conflicting feelings of the visionary personality (purple) toggling between control (tan) and freedom (yellow).

PURPLE-RED

Purple-red is a common color combination, with red usually presenting in the bottom half of the distribution map, and purple in the area above the head. This combination represents a mindset that revolves around an idea or creative thought or project (purple) with an internal/external effort of that dream being put into action (red). In this sense, red and purple complement each other: purple has the dream and red can actualize it. This isn't always a pleasant experience, though. Red can be intense, as it governs our sense of battle and survival. Red is the energy of a new business in its first year, a small-town youth moving to the big city to "make it," or an underdog athlete pushing themself. (Think of the classic training montage in the movie *Rocky*.) It's a do-or-die type of energy. There's plenty of courage to be found with red, but the road often isn't easy.

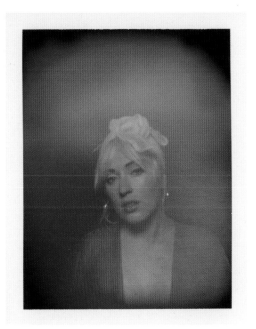
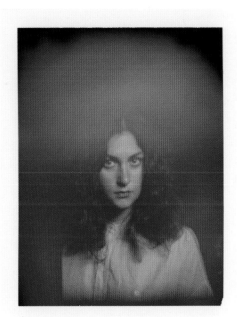
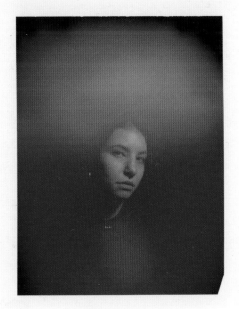

PURPLE-ORANGE

The purple-orange color combination is dynamic, indicative of an energetic type who is usually going full throttle; can be particularly passionate about a certain ideology, vision, or idea; and tends to thrive when working outside the mainstream. It's a difficult combination to keep in balance since both colors value independence and novelty, purple with its dreamlike tendencies and orange with its assertive spirit. But this combination points to someone who is readily dissatisfied with predictability.

Nothing makes this energetic type more miserable than being stuck in a dead-end situation—whether it's a mainstream job or an uninspired relationship, even a boring living environment. People who like to think big and take risks—entrepreneurs and freelancers, for example—typically present with this coloration. When purple and orange are well-balanced, the sky's the limit, and nothing seems impossible—the wildest ideas can lead to unique jobs, travel opportunities, and collaborative relationships; this energy type tends to have an interesting life, one that is full of spontaneity and freedom.

JOSEPH ALTUZARRA

The consistency of purple and orange in these photographs of fashion designer Joseph Altuzarra point to a purple-orange energetic identity. The purple in the lower left-hand side of the first (opposite, left; 2015) and then above his head in the second photo (opposite, right; 2019) indicates that what was first an internal experience became a mental one. Our energy fluctuates and moves from one state to another; if you're lucky, you can capture a color evolving through all three states. The orange-tan blend remained consistent in the upper portion of the lower right-hand corner of both photos; as a reflection of his outgoing energy, this suggests adaptability (orange) and an adherence to methodology (tan).

The differences in the images reflect the nuances of his daily life.

The intensity of the green in the lower right-hand corner of the first image indicates, along with the orange-tan, a strong dedication of energy toward achieving a goal or moving in a more specific direction. The same corner in the second photo is fully orange-tan with an underscore of red, indicating a little more change and practicality, then striving hard to achieve a goal. Comparing the lower left-hand corners, there's a significant difference between the light fluffy purple and heavy red. Internally, these are different experiences. Purple is dreamlike and concept-oriented. Red is more down to business, which is in line with the designer establishing his career and, four years later, continuing to work to realize his creative vision.

MAGENTA & INDIGO

All aspects of purple hold true for magenta; it's just that the volume's turned up a little higher. Magentas are almost always eye-catching in appearance, bucking the norms of mainstream fashion and crafting their own personal aesthetic. They can make even a T-shirt look runway ready.

Indigo sits between blue and violet—a color I don't see very often. This is one of the few colors that doesn't fall under the rule that the darker the hue the more negative qualities it suggests. Indigo is deeply sensitive, and that depth is usually represented by the darker hue. Unfortunately, indigo is also a coloration that, when not balanced, shows the potential for addiction or escapism. It's not unusual for indigo types to go through a phase where they try to numb the sensitivity they experience, especially during emotionally overwhelming times. That said, indigos will usually find a way to process this sensitivity through a spiritual or creative outlet.

I rarely see indigo without some flush of purple or magenta. Much like the blue-purple combination, an indigo-dominated person readily identifies as an introvert-extrovert or, as one indigo-magenta I photographed described it, an introvert with good social skills. Both types are naturally nurturing, connected to and affected by the people in their lives. Magentas and indigos often identify as healers or creatives and are often overwhelmed by busy public spaces. They usually have a sixth sense or an artistic gift and treat this gift as a spiritual commission. To avoid complicating such a pure personal experience with the complexities of a business, I rarely see them using this gift as their primary income source, although some have done so successfully.

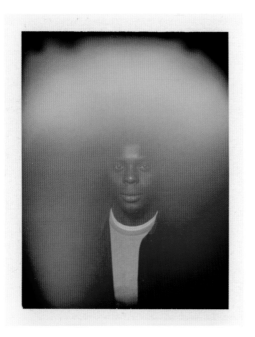
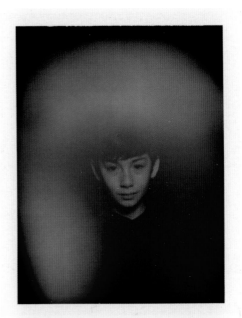
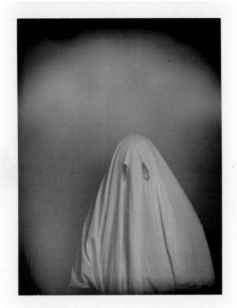
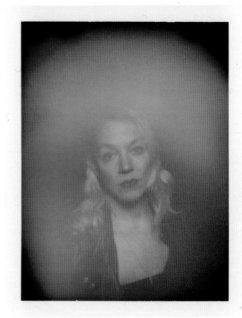

CHAPTER IX

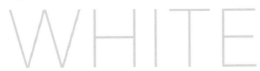

WHITE

White contains the entire color spectrum; we see every color of the
rainbow when a white light falls through a prism. High-end modernists
and minimalists have long championed the color, using it in designs that
communicate a sense of sleekness; but its origins in color psychology give
it a much more universal appeal. Westerners have a long history of equating
the color white with a sense of purity and cleanliness and with a state of
profound spiritual consciousness, or enlightenment.

I can't speak to white's power in this regard; I've never photographed
someone with an all-white aura. The most white I see in my aura photo-
graphs—or perhaps I should say the cleanest white, mixed with another
color—consistently displays as a blend or a gradient in the mental or internal
areas. At first, white perplexed me. Time and time again I noticed a strong
disparity between how my subjects identified with the color and how it's
historically been perceived in both color psychology and in relation to the
chakras or in spirituality and religion as being "pure" or "elevated." My
thinking was that since white is the embodiment of all color and since it
frequently shows up in the area above the head, which corresponds with
mental processing, people who photographed with a white band or arc were
simply feeling mentally overwhelmed. This thinking resonated with my
white-banded photography subjects, the majority of whom confirmed that
they were in a state of mental overload.

Over time, I've come to view this energy as "white noise." White
noise can, of course, be an amplifier and a distortion—it's both at once.

When white is adjacent to other colors, it dials up their volume. As an example, white with green usually indicates someone who's evaluating a lot of options about their life's direction. White with purple indicates someone who is inspired by so many different things, they may struggle to focus on one thing at a time; white with blue indicates someone who's overly sensitive. White basically amplifies each color's attributes and, at the same time, overwhelms the person experiencing them.

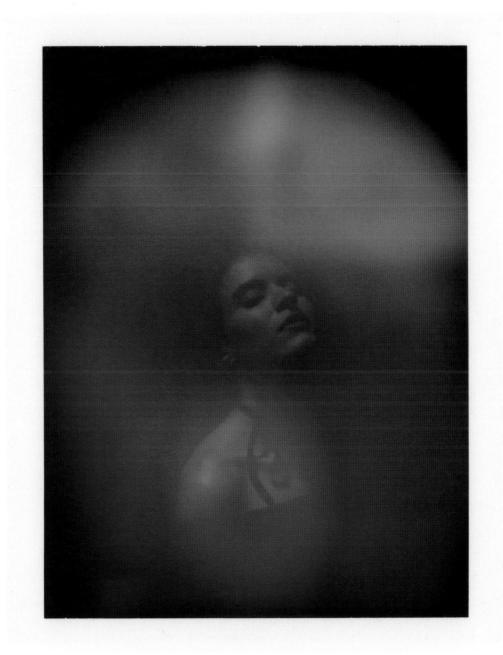

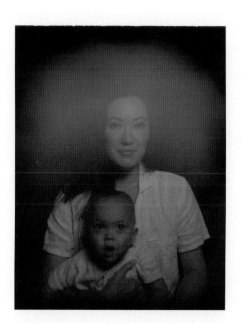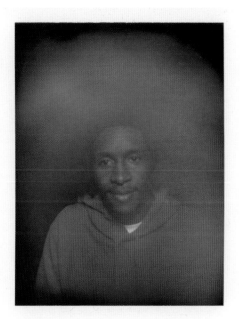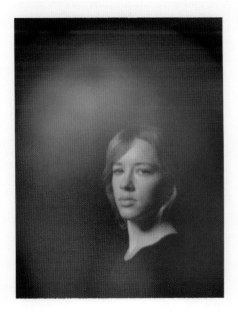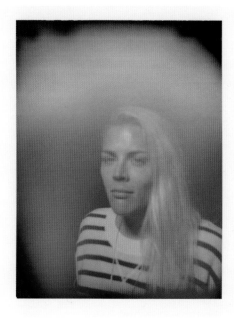

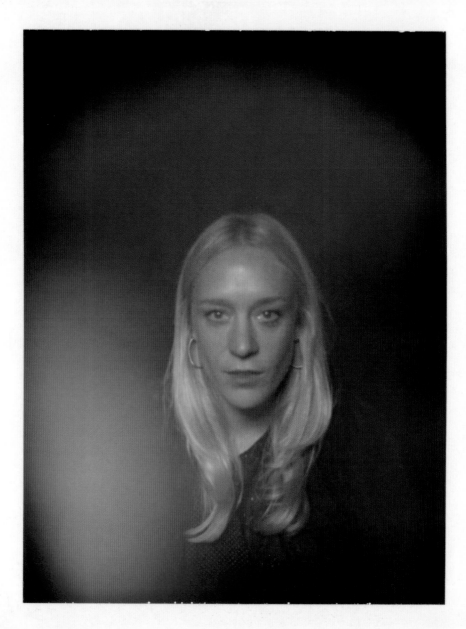

CHLOË SEVIGNY

Chloë has a lot of beautiful blue mixed with green, predominantly in the mental part of her image, and some purple-white in the lower left-hand corner, or internal area, of her photos. Green relates to ambition, long-term aware-ness, and future concepts, while blue has more to do with nurturing, sensitiv-ity, and giving to others. This blue-green combination indicates a creative person who's able to grow her career (green) while being both sensitive and aware of her surroundings as well as her impact on people (blue). (For more information on the blue-green combination, see page 149.) The white (enhancement) with purple (creativity) suggests a heightened creative ability along with the likelihood she's creatively inspired by myriad things. She also has white on blue, which points to a hyperaware individual, suggesting she herself is sensitive as well as highly attuned to the environment and those around her.

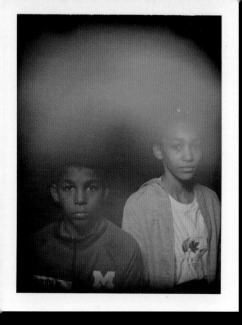
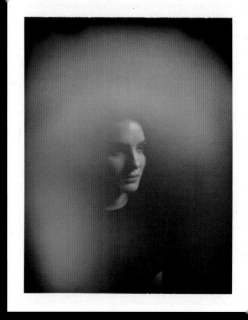
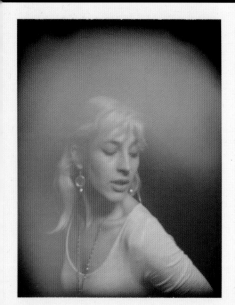
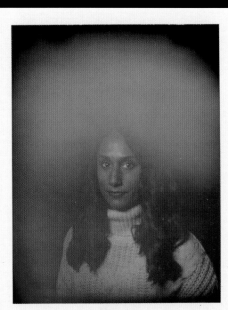

CHAPTER X
DUSTY ROSE

I've only seen dusty rose in the area above the head on the distribution map, which suggests it's an energetic state exclusive to mental processing. In my experience, dusty rose indicates a mental crossroads of sorts: I've seen the color appear on the photograph of a couple on a Tinder date who were trying to suss each other out. I took a photo of a businessman who was waiting to hear whether he'd been approved for a bank loan. On two separate occasions, I've taken photos of individuals who were waiting to hear from the US government on whether they'd be deported; they also showed dusty rose.

People often align dusty rose with the heart and love. I haven't seen this to be the case when photographing the aura. If this were true, though, dusty rose would also appear in the lower corners of the distribution map, which indicate an internal experience, and as an expression in the external area. In my experience, I haven't found a correlation between matters of the heart and the color. Dusty rose is merely indicative of a mentally uncertain experience.

OPPOSITE: Pink isn't part of my descriptive vocabulary when analyzing an aura photograph because it is too general. I've also found that many people see certain tones of purple as pink. In my experience, pink appears in distinct tonalities, usually taking the form of a dusty rose or magenta. I use these two terms to differentiate clearly between pink and purple.

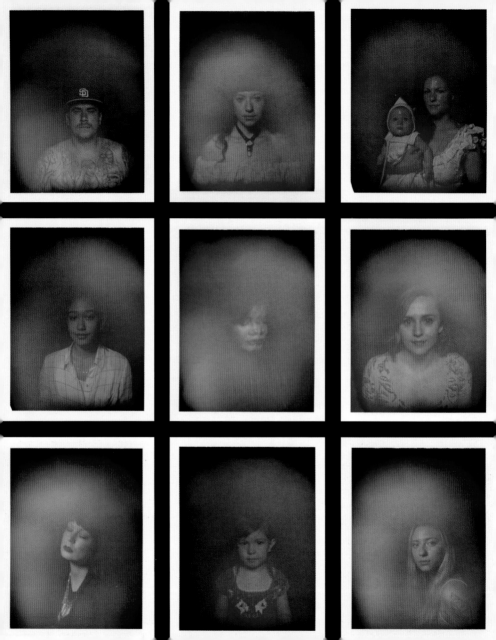

RAINBOW

Rainbows are beautiful to look at but, in my experience, such an array of vibrant colors in an aura photograph is the embodiment of an energetic supernova—it's bright, it's beautiful, but it might explode. People, and commonly children, who photograph as rainbows have a lot going on energetically and can sometimes run the risk of burning out or feeling drained and needing a nap. People who identify as empaths frequently photograph with rainbows. The quality of the rainbow makes a difference: well-balanced, proportionate colors indicate positive energetic health and an equilibrium between competing energies; a swirl of colors that contradict one another indicates a state of unease or chaos. To have a rainbow, there must be more than three colors present. Most rainbows have a gradient of several colors in one area of the distribution map and different colors in the two other areas.

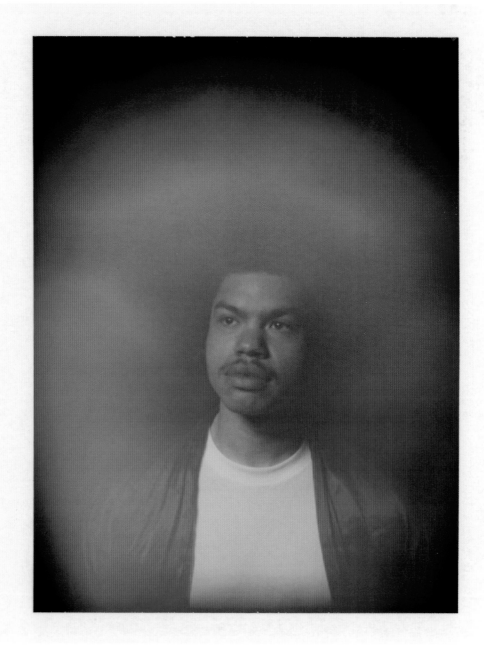

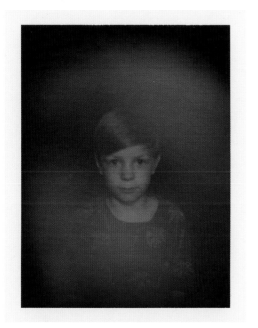
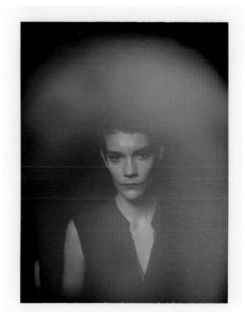
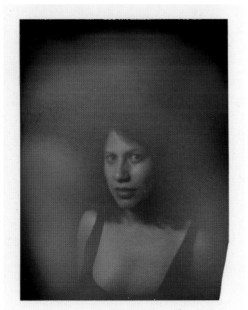
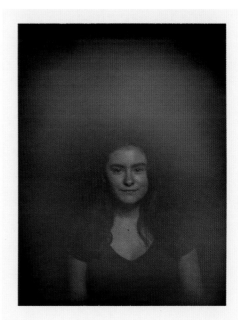

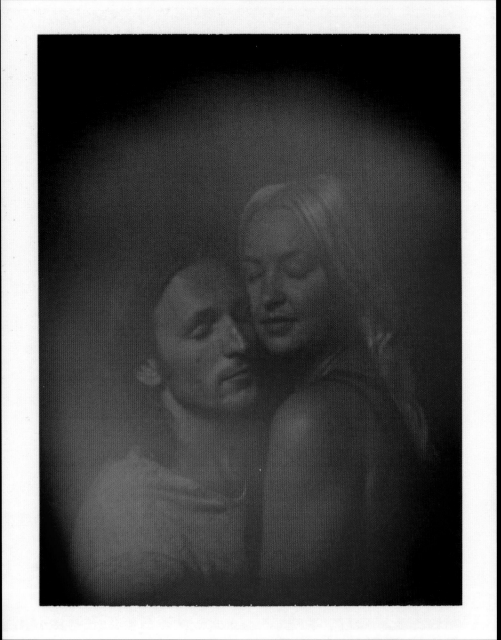

A ROMANCE
Katie Bointe and Tanner Hoss

This photograph captures the energy of a very compatible couple. The first thing that captures my eye is the formation of the colors. The nice broad stroke of magenta and red in the area above their heads—their mental energy—shows that this couple gets validation from the physical manifestation (red) of a concept or a vision that is unique to them (magenta). This same red-magenta is also located in the center of the photograph and radiates outward in a captivating orb. I've seen this formation before. It indicates either stress or passion; given this couple's overall color dynamic, I would guess the latter. This is a great example of how red doesn't always mean aggression; it can simply imply a strong physical expression.

The blue band indicates that they both value the relationship. And the soft blue-purple-white in the lower left-hand side of the photograph suggests that they both prioritize connection (blue) on a variety (white) of ideas and belief systems (purple). Because the external area (lower right corner) is so faint, I'm guessing that they're not engaging much with their external energy. Instead, it looks like they are in full "honeymoon phase," preferring to connect with each other over the outside world.

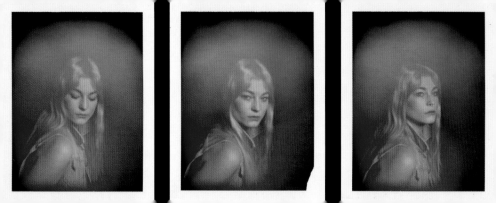

ENERGETIC LANDMARKS

The way the colors combine, blend, and interact with one another determines their meaning, as does their placement on the distribution map. Besides having a working knowledge of the different characteristics of the aura photograph—bands, bruises, gradients, shades/blends, and dots—it's also good to be familiar with two other concepts: color shifting and color identity.

OPPOSITE: People occasionally color shift: You can see here how Megan shifts from having no color in her external corner to a full blue when she looks directly at her reflection in the camera, then back to nothing when she looks away. One can surmise that her persona embodies blue characteristics. When she sees herself, she puts forward energy that is sensitive and nurturing, and she is, in general, someone who prioritizes having a sense of connection. You can see this same phenomenon in my own self-portraits on page 37.

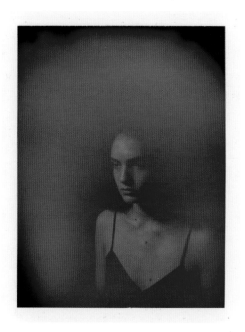
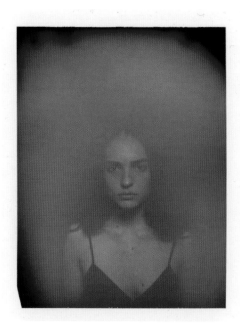
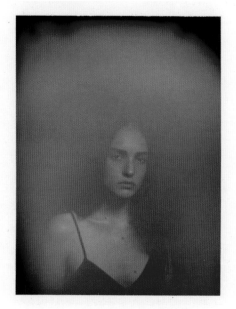
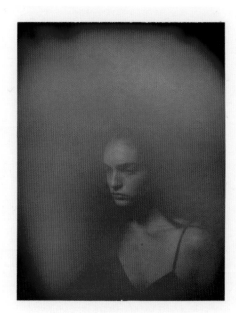

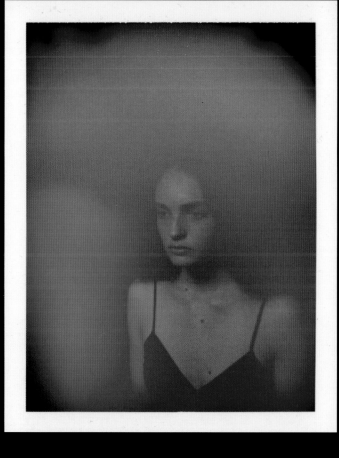

In this series of images, there are slight changes in the external area, yet the colors have remained generally consistent. I have not found any positive or negative associations with whether you do or don't color shift; I simply hold it as a reflection of how you energetically respond to the moment.

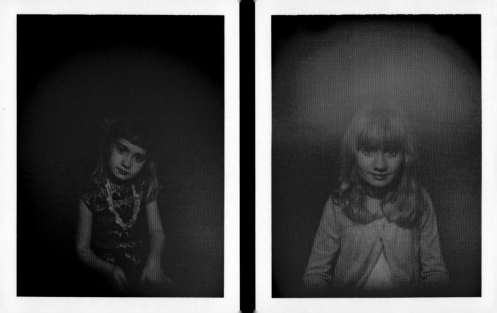

COLOR SHIFTING

Color shifting is a remarkable phenomenon and is exactly what it sounds like: a person's color will change from blue to green, for example, sometimes within seconds of having their photo taken. Energy, as is turns out, can be a fluid and sensitive entity, subject to change both subtle and drastic within a short period of time. I first recognized this phenomenon in 2014 when I took multiple images of a model, one right after the other. Despite the photos having been taken within moments of one another, the colors were slightly different in each image. Since then, I've repeatedly noticed this phenomenon, and I will often take a quick series of photographs to test it. What I've learned is that it really depends on the individual. The majority of the time, people remain consistent with their colors, and yet sometimes they shift. Color shifting is generally more common in the lower right-hand corner, especially among people who interact with their reflection in the lens of the camera, or above the head. I attribute this to the fact that our thoughts are malleable—we often change our minds and alter our thinking on the spot.

Color shifting can happen in a matter of seconds or a matter of years. I have been fortunate to have a community that regularly "checks in," creating what I call a visual diary. Here is a series of images that have evolved, not in a matter of seconds, but in a matter of months and years, each photo marking points on our life path.

OPPOSITE: These images, taken three years apart, illustrate beautifully how a young girl's experience of the world gradually expanded from an insular to a more complex one, as evidenced by the appearance of a new color—in this case, purple—in her mental area.

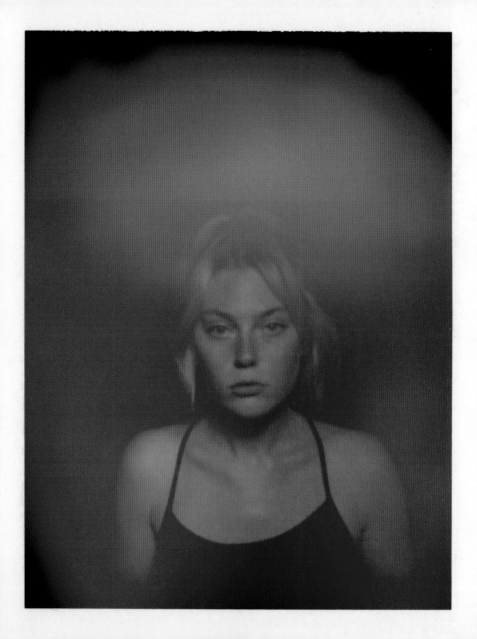

Visual Diary

HANA GUSTAFSON

Hana is a great representation of someone who color shifts. I have photographed her consecutively for about five years. Despite color shifting, the same pattern of colors showed up. They were just arranged differently every time: brilliant reds, purples, and oranges countered by dim and sometimes murky blue-green, back to red-purple again. She even displayed a rainbow. In her third aura photograph, Hana displayed blue and green, and her description of that energetic experience is common to what I hear from many blue-greens. She said, "I associated blue with my mental denial and the inability to end a dying relationship. . . . Green is growth: I was no longer denying but rather accepting that the relationship wouldn't fulfill me long-term." The blue-green dynamic often speaks to a common conflict: which do we prioritize first, the relationship or the self?

OPPOSITE: "The summer months allowed a necessary escape from rigorous course work. As a junior in college, I was a determined ancient-art historian focusing on the initial instances humans engaged in a creative practice. I was contemplating time and place—both figuratively and literally." —Hana, August 2016

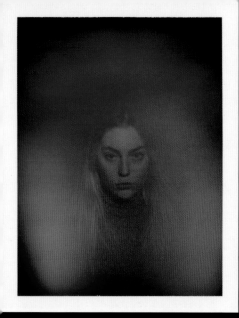

ABOVE, LEFT: "This is my second aura portrait, taken on my twenty-second birthday and two weeks into what would be a two-year relationship. I'm a rainbow: I was feeling everything and simultaneously nothing. Excitement about a new partner and stunted by my own fears of the future. I was applying to graduate school, attending college, and working—I was exhausted. Financially I was stressed, and mentally I was being pulled in every direction. Depression and elation." –Hana, January 2017 **ABOVE, RIGHT:** "I wanted my aura to display growth, but as long as I was with this person I was stuck; I'd favor comfortability over pushing myself." –Hana, August 2018

ABOVE, LEFT: "When I'm sad, I put my best face forward. Here, the coloration of my consciousness is purple like my first aura portrait. Red represents new beginnings. Tan and orange capture the independence I felt with the adoption of my first pet. I was sad but hopeful." –Hana, February 2018

ABOVE, RIGHT: "I met someone new, someone who makes me happy. . . . I'm writing my thesis and thinking about life post graduate school. I'm free and excited for what's to come. Green is growth; confirmation of my personal and educational success is captured in the pigment of this photograph." –Hana, October 2018

I've photographed Sanam Sindhi more than five times and in three different cities. I was curious to see how much, if any, a location would influence someone's energy. Each time, she surprised me with a new range of colors, no matter the location. She's a great example of someone who color shifts; her energy is always vibrant and, to me, is an example of someone who energetically fluctuates with the dynamics of her life.

Our first photo together (opposite) was in the Lower East Side of New York City in 2016. Here, Sanam has a rainbow, but a very compartmentalized one, meaning that there isn't much crossover in the distribution map, suggesting a sectionalized energy.

Her internal color is a blend of purple, blue, and white, which means that she's both sensitive and concept driven on a variety of subjects. This is an interesting balance to the external energy of tan and orange, which indicates that while Sanam is quite sensitive, she doesn't readily show that sensitivity to just anyone. Both orange and tan are known for avoiding vulnerability. In the mental area, you can see a very clear negotiation between green and blue, which indicates mental friction: between giving and taking, home and career, emotion and logic.

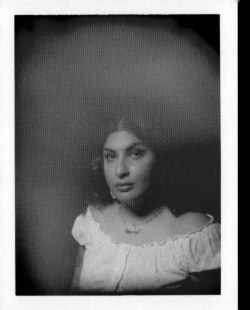
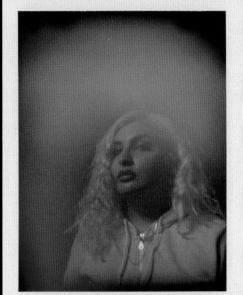

I saw Sanam in Los Angeles a year later (opposite, left). She had just moved there, so I wasn't surprised to see a great deal of red in her mental area and external area, as the color signifies new beginnings. Above her head, a red-orange blend indicated that she was thinking very creatively as well as getting down to business. It was a pleasant surprise to see that she still maintained the same level of creativity (purple) in the lower left corner from the previous year, while shedding the white-with-blue of extreme sensitivity. The consistency of the purple and orange demonstrated that even though there's a lot of red, her internal value system as a creative person has remained intact.

The year 2018 (opposite, right) was one of change and uncertainty for Sanam; the red in the lower left corner indicates change, a process of rebirth. The dusty rose in the mental area suggests Sanam is thinking about something but hasn't come to resolution on the issue; blue, which is usually internalized, is now front and center in the external area. Her heart is on her sleeve. This was such a drastically different photo from her previous images, I knew something was up. Turns out she had just survived a very bad car accident and was still coming to terms with some fundamental beliefs about her life.

Visual Diary

MAGNOLIA AND JASPER

These images of siblings Magnolia and Jasper demonstrate the evolution of one's persona, from childhood to the early tween years. I photographed them over a consecutive three-year period, beginning when Magnolia was nine and Jasper was eleven. The colors become more complex as the siblings get older and have more agency.

I've noticed that children exhibit rainbow colors in the toddler years. Between about four to nine years old, they level out, photographing with one or two colors. As they approach the teenage years, they begin to photograph with more colors.

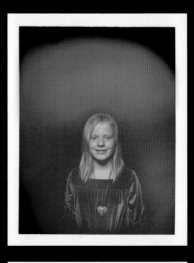

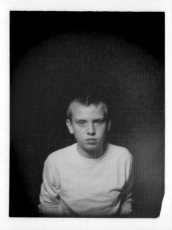

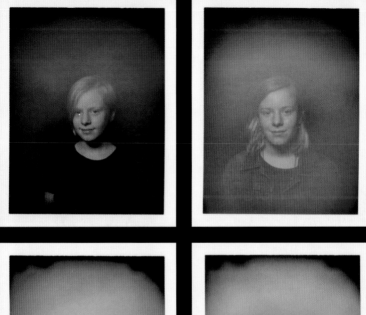
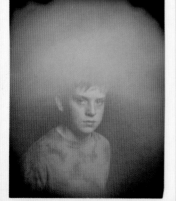
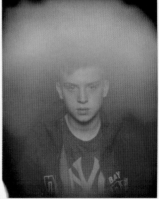

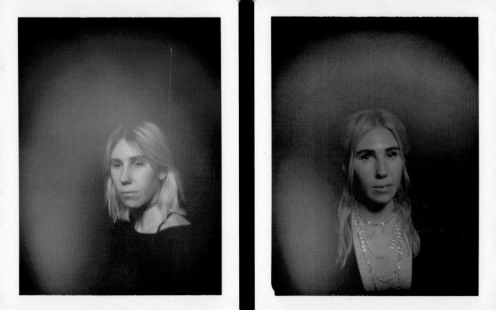

ENERGETIC IDENTITY

While some individuals show a remarkable range of energy, color shifting from one photo session to the next, other individuals possess an energetic identity, whereby they consistently photograph with the same color or color combination. I have found that it's best to take at least three separate photos over several months to identify a pattern, which is to say an energetic identity.

Individuals with a strong color identity react to the ups and downs of everyday life with a consistent energetic orientation . . . until they don't. A major life transition can sometimes cause a color shift, which leads me to believe that an energetic identity simply exemplifies how some people stay rooted in a particular energetic tone longer than others, and that perhaps their life situation dictates a particular kind of energy that can't change until a situation forces it to. There's a profound sense of self when you find that you photograph consistently with one color; it becomes an extension of who you are, a key to your perceived sense of reality. Currently, I tend to photograph with purple-blue as my energetic identity, so when I photograph with purple-blue-green, it is not a question of interpreting how the colors sit in relationship to each other and interact, but an indication of a purple-blue person going through a green experience. The presence of these other colors becomes energetic landmarks to key moments in our lives. When aura portraits are viewed consecutively, we not only gain the perspective to see where we've been but also get an energetic preview of where we might be headed.

OPPOSITE: Zosia Mamet at a public event, 2015 (left), and on the evening of her marriage, 2016 (right). These are vastly different experiences, yet her internal state (the lower left of each image) and her external state (lower right) remained the same, pointing to a consistent energetic identity.

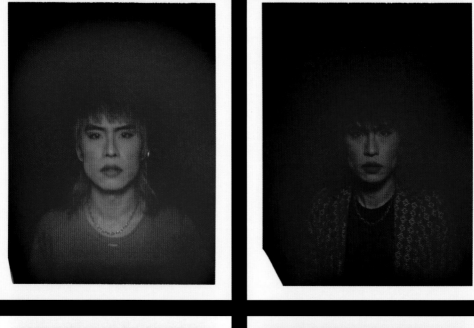
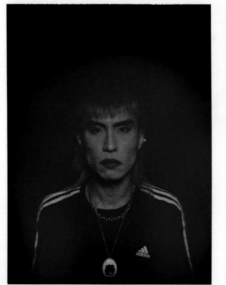

Visual Diary

NICKY KAY HIN IP

All of these images of Nicky were taken within two months of each other. As you can see, Nicky's experience of, in his words, "dealing with depression and anxiety" hasn't dramatically changed the aura—just the hue and size are slightly different. We are unique in how we energetically process our experiences; although muddy red is quite common, I haven't noticed one color or formation to be the signal for depression and anxiety.

OPPOSITE, CLOCKWISE FROM TOP LEFT: December 2018; February, April, and June 2019.

Visual Diary

LOUISIANA MEI GELPI

Louisiana Mei Gelpi is a perfect example of someone with a strong color identity. I first took Louisiana's photo in 2015 and have photographed her every year since. She's consistently showed with purple as her prevalent color for four years in a row. When she graduated from college in 2019, her colors shifted dramatically to a vibrant green, which made sense since she was transitioning out of the world of academia where ideas and thoughts (purple) are paramount, and into the work world, where more value is placed on transforming ideas into a career path (green).

2015: VALIDATION

There's a noticeable amount of purple in the mental area, representing someone who's conceptual. The hue is bright, and the appearance of the color is very clean, indicating a very healthy energy. Louisiana is validated in her inspiration, perspective, and beliefs. The darker muddy purple-red in the lower left corner indicates that she may need more self-care, and lots of red in both lower corners indicates a new beginning of some sort. The orange-red blend in the lower right-hand corner suggests that she's applying her energy in an adaptable and practical way.

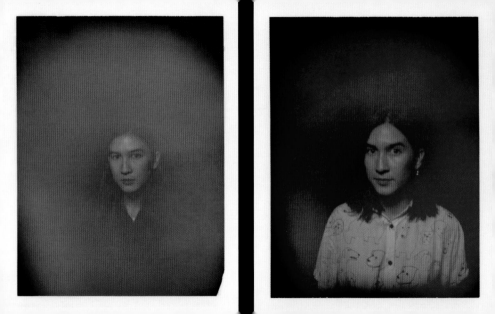

2016: INTERNALIZING HER INSPIRATION

One year later (opposite, left), and the purple in the mental area is remarkably consistent. Her internal area has shifted from muddy red to purple, indicating that she has recovered from whatever drained her last year; she is now internalizing her inspiration. When there's purple in both the mental and the internal area, and the hue is bright and clean as is the case here, it usually indicates someone who's in harmony with their thoughts and beliefs. The faint halo of red around her head suggests some hard work. The gradient of tan-yellow-green in the lower right-hand corner means she's putting forward a mixture of energy. Yellow represents her enthusiasm; tan, her logic and attention to detail; and green, her goals and ambition.

2017: TRANSITION

This is the third photo (opposite, right) over the course of three years in which she's consistently displayed purple. This is a very cool illustration of what a purple energetic identity can go through: in the previous two photos, Louisiana had red aspects coupled with purple, and now for the first time there's blue. She's energetically shifted from being in a state of survival, practicality, and hard work (in regards to her vision/purple) to a state of sensitivity, belonging, and connection. Blue isn't in one area but two: the mental and the internal. The gradient above her head indicates a dynamic: she's a purple person going through a blue experience. Her external area, interestingly enough, is the same purple found above her head in the previous two photos. What was just a concept is now an expression

2018: HEART HEALTHY

Four years in a row (opposite, left) and there's the same tone of purple in the mental area, and now for the first time it's in the heart area as well, which tells me that beliefs, concepts, and perspectives that she's been processing mentally are now also in her heart. I often see this coloration and positioning among artists who are passionate about their craft. The red in the internal area suggests that that she may be going through changes or is in a state of survival. The blue in the external area indicates that she's more sensitive than usual about her surround-ings or is dedicating a lot of energy

2019: DRAMATIC CHANGE

This photo (opposite, right) floored me when I saw it. What is all this green? Where is the purple? I knew there had to be an explanation for such a drastic color shift. The red that is so indicative of change was still present from her previous photograph, only now it blended with entrepreneurial orange. The green above the head and in the lower right-hand corner was bruised and darker in hue so I knew she was most likely being hard on herself in regard to a goal. She told me she just graduated college and was trying to establish her career in her major, photography—a perfect representation

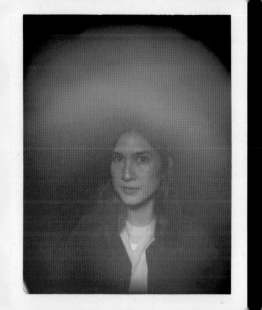
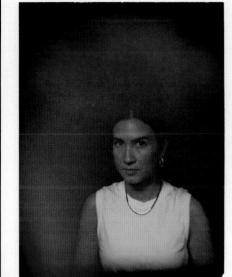

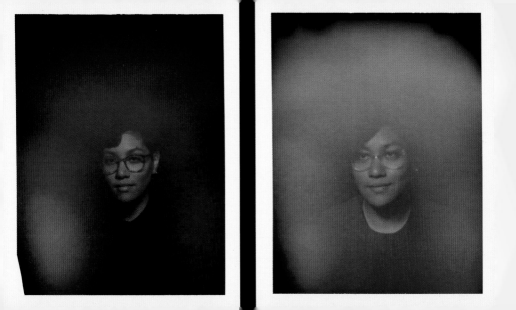

Visual Diary

NINA KOSSOFF

Nina's photos, taken six months apart, are illustrative of someone who has been remarkably steady over the years. The first image (opposite, left) was taken after an "intense emotional breakup" and is the outlier among them all. Notice the blue-green that is so indicative of boundary setting, a common color I see when someone is trying to come to terms with their own needs in regard to a commitment of some kind. In the second photograph (opposite, right), purple takes her to brighter places, first with the adaptable yet cautious orange-tan mental energy, coupled with the new beginnings of red in the exterior area. This tells me that Nina is becoming more social and stepping out of her comfort zone, which she affirmed, saying, "Now distanced from my summer breakup, I was having fun again, doing things for myself and relearning my own wants, needs, boundaries, and joys."

OPPOSITE, LEFT: "I had just gone through a wildly intense emotional breakup about a week before this photo was taken and was just beginning to dig through everything—the good and the bad—that I was feeling." —Nina, July 2016 RIGHT: "I was with the same two friends I had been with the first time I got my photo taken. Each of us saw some clear shifts in color, but mine was a total reversal into warm colors. It was deeply reassuring that I was doing what was right for myself; it was a shift I needed." —Nina, December 2016

The third photo (opposite, left) displays a nice, clean bright hue of purple in the mental area, and red in both corners. The red is a little dark on the lower left indicating fatigue, but overall, it's a nice strong ruby red in the exterior. This tells me that Nina is embracing change and challenge in a healthy, sometimes exhausting way. At the time of this photo, Nina was in a relatively new relationship that, in her words, "had me experiencing ways of giving and receiving love that I didn't necessarily know I could have. Everything was playful and easy, despite a lot of intense things happening outside of us."

The purple in the last photograph (opposite, right) is still consistent in the mental field, with a nice ruby red in both corners below. Seeing that Nina has a nice bright hue in all areas and has remained consistent with the previous photo suggests that she's found a good cadence in her life and that this energetic identity is in a state of validation. She had started a new job and was continuing to build on her relationship. Despite these life changes, her colors—especially purple and red—have remained consistent, a good example of an energetic identity.

OPPOSITE, LEFT: "I was in the first months of a new relationship when this photo was taken (still going strong today)." – Nina, July 2017 **RIGHT:** "I had just started a new job in October and was continuing to build the most loving relationship I've ever experienced. . . . This was the first time I brought all of my photos to the session with me. When I looked at my face from July 2016 compared to this latest photo, I could see the shift in my self-confidence; it was wildly reassuring that my instincts and shifts—everything—were where I needed and wanted to be." –Nina, December 2017

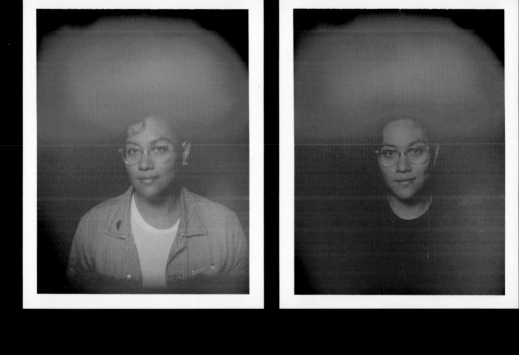

LIVING COLOR

For me, conversations about the self boil down to the nature of perception, a subject everyone from philosophers like Plato and Socrates to artists like James Turrell and Cindy Sherman have grappled with over the centuries. My goal in creating Radiant Human was to explore our inner "light"—our energy—and gain a better understanding of how we define both our sense of reality and our sense of self. I've learned that we're energetic works in progress. We are forever shifting, seeking balance in a world or in situations that challenge our emotional and mental strengths, calling us to action. We calibrate and recalibrate ourselves with each new relationship, life change, or energetic dynamic.

Much of our experiences in life and our attempts at self-understanding exist on the edge of what can actually be seen. The aura photograph not only helps us see the spaces between human perception, our energetic experience, and our physical existence but also captures a moment in time so we can share or reflect on it. It's a timestamp, a visual diary. The aura photograph bears witness to some of the great energetic landmarks of our lives—whether we're enduring a breakup, a global crisis, discovering a new career path, or setting new personal goals. And just as there is beauty in the imperfect, impermanent, and incomplete, so there is too in the transcendent portrait, painted in the long and short strokes of colorful wavelengths. In an image-obsessed world, my hope is that the photographs presented here have helped reveal the reality of ourselves more honestly—because who are we if not our energy.

ACKNOWLEDGMENTS

Endless thanks to all the Radiant Humans who have shared their stories and their photographs. There were honestly too many to choose from. If it weren't for the diligent and generous efforts of my photo editor Christiana Caro and my designer Su Barber, I would still be lost in a delightful yet overwhelming sea of four thousand-plus images from my personal collection. My never-ending gratitude to Elizabeth Viscott Sullivan and Signe Bergstrom and the rest of the HarperCollins team for believing in me and this book. Thank you to Lauri Freedman and everyone at the Whitney Museum of American Art for giving me space. Warm thanks to Glenda Bailey at *Harper's Bazaar* and Goop for giving this girl her break and, lastly, a special thanks to my dream team: my agent Meg Thompson, Bryan Wasetis, and Melissa Dishell.

Additional thanks to the following individuals: Mom and Dad; Athena; the Friend Family; Erin Dooley; Monica and Souther Salazar; National Forest Design; Meredith Jenks; Lisa Butterworth; Kenric McDowell; Jasper Guest; Zosia Mamet; Chloë Sevigny; Busy Phillips; Joseph Altuzarra; SZA; Pharrell Williams; Michelle Melton; Jill Lindsey; Monica and Justin from Individual Medley; Amy and Noah of Novelle Novelle; Nic from Homestead; Alea Joy; Katie Campbell; Shanna Hill; Amanda Walker; Bettina Prentice; Kim Krans; Kristen Cattell; Charlotte Ferguson; Valorie Wallace; Charlotte Wenzel; Hannah Stouffer; the Vom Dorp family; and last but never least, the Deler, Garcia, and Lopez families, thank you for giving me a home in your hearts.

SELECTED BIBLIOGRAPHY

Campbell, Joseph. *The Inner Reaches of Outer Space*. New York: Harper & Row Publishers, 1986.

Georgia O'Keeffe Museum. Accessed May 19, 2020. www.okeeffemuseum.org.

Jung, C.G. *Four Archetypes*. Princeton, NJ: Princeton University Press, 1973.

Kilner, W.J. *The Aura*. New York: Samuel Weiser, Inc., 1973.

Lüscher, Max. *The Lüscher Color Test*. New York: Random House, 1969.

Moss, Hugh. *The Art of Understanding Art*. London: Profile Books, 2015.

Oslie, Pamala. *Life Colors*. Novato, CA: New World Library, 2000.

Pastoureau, Michel. *Blue: The History of a Color*. Princeton, NJ: Princeton University Press, 2018.

––––––. *Green: The History of a Color*. Princeton, NJ: Princeton University Press, 2014.

––––––. *Red: The History of a Color*. Princeton, NJ: Princeton University Press, 2017.

St. Clair, Kassia. *The Secret Lives of Color*. New York: Penguin Books, 2017.

Walker, Alice. *The Color Purple*. New York: Harcourt Brace Jovanovich, 1982.

Wauters, Ambika. *Chakras and Their Archetypes*. Berkeley, CA: Crossing Press, 1997.

PHOTOGRAPHY AND ILLUSTRATION CREDITS

All the photographs in this book were taken by Christina Lonsdale, © Radiant Human, unless otherwise noted here.

Many thanks to everyone who gave us permission to use their image as part of this project.

PAGE 8: Photographer unknown. Courtesy of Charles Lonsdale.

PAGE 11, TOP AND BOTTOM: © Dennis Stock/Magnum Photos.

PAGES 12–13: From the collection of Charles Lonsdale. Courtesy of Charles Lonsdale.

PAGES 14–15: Photographer unknown. Courtesy of Athena Lonsdale.

PAGE 16: Painting by Maria Mikhailas. Courtesy of Maria Mikhailas.

PAGE 19: Flyer for rave held by the League for Spiritual Discovery, 1994. Designer unknown. From the collection of Christina Lonsdale.

PAGE 20: Photograph by Athena Lonsdale. Courtesy of Athena Lonsdale.

PAGE 32: Photograph by Michael J. Spear. Courtesy of Michael J. Spear.

PAGE 33: Diagram design by Sam Lee. © and courtesy of Radiant Human.

PAGE 236: Photograph by Jaclyn Campanaro. Courtesy of Jaclyn Campanaro.

PAGE 240: Photograph by Natalia Mantini. © 2020 Natalia Mantini.

HarperCollins books may be purchased for educational, business,
or sales promotional use. For information, please email the
Special Markets Department at SPsales@harpercollins.com.

First published in 2021 by
Harper Design
An Imprint of HarperCollins *Publishers*
195 Broadway
New York, NY 10007
Tel: (212) 207-7000
Fax: (855) 746-6023
harperdesign@harpercollins.com
www.hc.com

Distributed throughout the world by
HarperCollins *Publishers*
195 Broadway
New York, NY 10007

ISBN: 978-0-06-287715-4
Library of Congress Control Number: 2020017941

Book design by Su Barber
Printed in China
First Printing, 2021

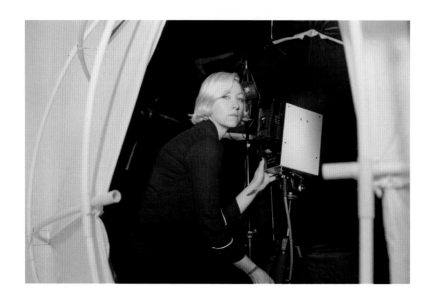

ABOUT THE AUTHOR

Christina Lonsdale is a conceptual artist who came to prominence through her photography project, Radiant Human, where she utilizes the AuraCam 6000 to explore the connection between energy and identity, a discipline that shores up the distance between New Age self-discovery and New Media self(ie)-actualization. Dubbed "the Annie Leibovitz of aura photography" by the *New York Times* and a "Dutch painter on acid" by *Vogue*, she has been an artist in residence at the Whitney Museum of American Art, shot aura photographs on site at the Museum of Contemporary Art Tucson, and worked with numerous brands including Nike, Google, Nordstrom, Refinery29, and Urban Outfitters. Her work has been featured in the *New York Times*, *Vanity Fair*, *ID*, *Vogue*, *Harper's Bazaar*, *Domino*, *Nylon*, and *Time Out*. She lives in New York City.

radianthuman.com
Instagram: @radianthuman_
Twitter: @Radianthuman_